D0574707

NEW MEXICO

BOOKS BY JOHN ANNERINO

PHOTOGRAPHY & ESSAY

ARIZONA
A Photographic Tribute

INDIAN COUNTRY
Sacred Ground, Native People

VANISHING BORDERLANDS
The Fragile Landscape of the
U.S.-Mexico Border

DESERT LIGHT
A Photographer's Journey through America's
Desert Southwest

CANYON COUNTRY
A Photographic Journey

GRAND CANYON WILD
A Photographic Journey

APACHE
The Sacred Path to Womanhood

ROUGHSTOCK
The Toughest Events in Rodeo

PEOPLE OF LEGEND
Native Americans of the Southwest

THE WILD COUNTRY OF MEXICO
La tierra salvaje de México

CANYONS OF THE SOUTHWEST
A Tour of the Great Canyon Country from
Colorado to Northern Mexico

HIGH RISK PHOTOGRAPHY
The Adventure Behind the Image

THE PHOTOGRAPHER'S GUIDE
TO THE GRAND CANYON

THE PHOTOGRAPHER'S GUIDE
TO CANYON COUNTRY

NEW MEXICO

A Photographic Tribute

JOHN ANNERINO

globe pequot press
Guilford, Connecticut
www.GlobePequot.com

To buy books in quantity for corporate use
or incentives, call **(800) 962-0973**
or e-mail **premiums@GlobePequot.com.**

Map by Gage Cartographics © Morris Book
Publishing, LLC
Layout: Maggie Peterson
Editor: Meredith Rufino
Project editor: Meredith Dias

Library of Congress Cataloging-in-Publication
Data is available on file.

ISBN 978-0-7627-7426-5

Printed in China

10 9 8 7 6 5 4 3 2 1

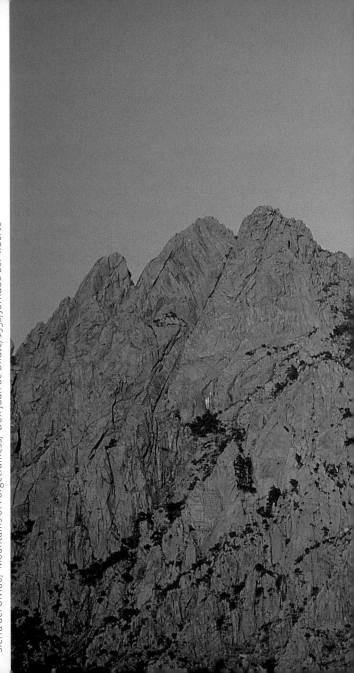

Sierra del Olvido, "Mountains of Forgetfulness," Don Juan de Oñate, 1958, *Jornado del Muerto*

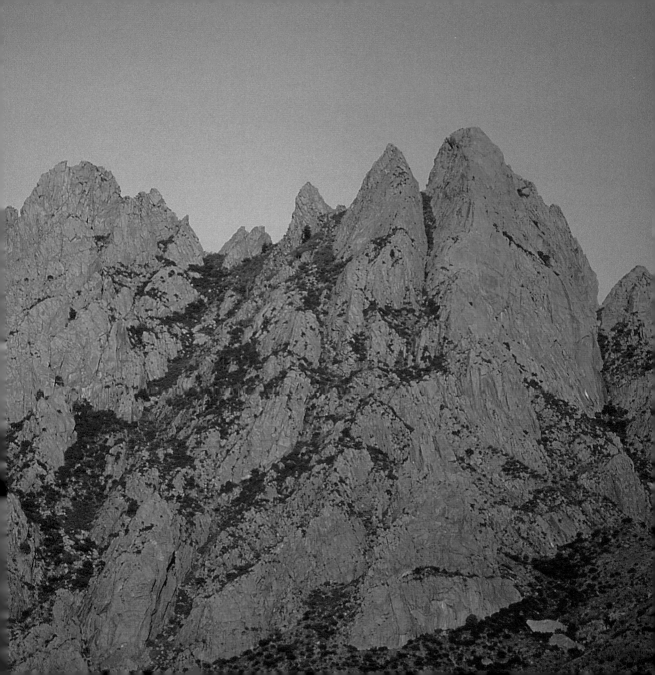

PHOTO NUMBER, LOCATION

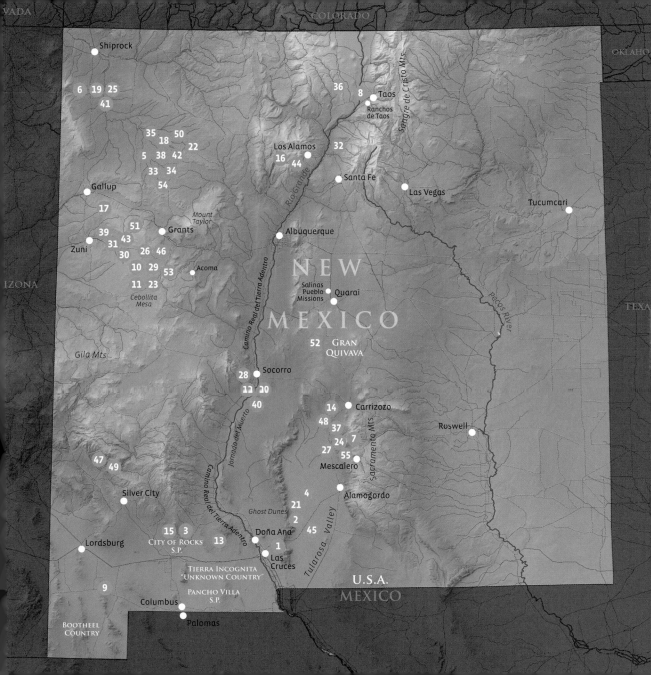

NEVADA

COLORADO

OKLAHOMA

ARIZONA

TEXAS

NEW

MEXICO

U.S.A.

MEXICO

Shiprock

6 19 25
41

35 18 50
5 38 42 22
33 34
54

Gallup

17

39 51
31 43
30 26 46
10 29 53
11 23

Mount
Taylor

Grants

Zuni

Acoma

Cebollita
Mesa

36
8 Taos

Ranchos
de Taos

32

Los Alamos
16
44

Santa Fe

Las Vegas

Tucumcari

Albuquerque

Salinas
Pueblo
Missions

Quarai

52 GRAN
QUIVAVA

Socorro

28
17 20
40

14 Carrizozo

48
37
24 7
27
55
Mescalero

Roswell

47
49

Silver City

Ghost Dunes

4
21
2
45

Alamogordo

Tularosa Valley

Sacramento Mts.

Lordsburg

15 3
CITY OF ROCKS
S.P.
13

Doña Ana

1

Las
Cruces

TIERRA INCOGNITA
"UNKNOWN COUNTRY"

9

Columbus

PANCHO VILLA
S.P.

BOOTHEEL
COUNTRY

Palomas

Sangre de Cristo Mts.

Rio Grande

Pecos River

Camino Real del Tierra Adentro

Jornada del Muerto

Camino Real del Tierra Adentro

Gila Mts.

"Chaco Canyon . . . contains the finest remains of an ancient civilization north of Mexico. . . . This great crossroads of all clans figures so prominently in the migration legends that we made two trips to Chaco Canyon, taking Hopi informants with us."

—Frank Waters, 1963, "The Race Tracks at Chaco Canyon"

It is silent. I am standing alone in the middle of nowhere. And the faint breath of light whispers across the cold black landscape. In the distance, I see stars still flickering over a low-lying butte. It slowly emerges from the darkness that's cloaked the barren, mile-high plains since sunset the evening before. Nearly lost in this vast sweep of desert of the San Juan Basin, Fajada Butte was the prism through which ancestral Puebloans once viewed the alignments of the sun, moon, and stars that still reign over this timeless landscape. Detached from the narrow peninsula of Chacra

Mesa, Fajada Butte would be dwarfed by the great landforms of Arizona's Monument Valley and the soaring mesas of Utah's Islands in the Sky. Yet, it commands my attention as I shiver in the crisp morning air before first light.

In the east, a sliver of light slowly begins to glow. It glimmers yellow, pink, then blue. It is a rainbow from the *Haashch'eeh diné,* "Holy People," as the Navajo sing in *The Night Chant:* "With the rainbow hanging high on the ends of your wings, come to us soaring!" The light dances across the rimrock of the Chacra Mesa and Fajada Butte, brushing them yellow, gold, and bronze. The sun bursts over the horizon, and dawn enshrouds the landscape with color I can almost hear. Daylight is born.

I drive up the road toward the mouth of Chaco Canyon. The entrance gate is still padlocked. When the park ranger arrives, he tells me what I already know. "You've got the place to yourself." As popular as Chaco Canyon is in our nation's collective consciousness, it is off the grid. You have to disconnect to journey here. There is no cell phone reception, no Wi-Fi, no gas stations. Spaniards who made sixteenth-century *entradas,* "entries," into the mysterious lands of *Nueva España,* called the landscape a *despoblado,* "uninhabited land." Settlers called it a "territory." On such a wonderfully clear, beautiful winter morning, the respite from modern civilization is a good thing. I make my way toward the kivas of Pueblo Bonito. The masonry walls, hand-laid with stones and talus from the towering cliffs behind them, glow with the warmth of the morning sun. Built by ancestral Puebloans between AD 850 and 1150, Pueblo Bonito, "Beautiful Town," was named by the Mexican guide Carravahal who led Lieutenant James H. Simpson here in 1849 during the Military Reconnaissance from Santa Fé, New Mexico, to the Navajo Country. Pueblo Bonito was home to fifty to one hundred people for three hundred years before the master "dry farmers" vanished in the face of the Great Drought. Or they simply migrated in many directions and resumed life as the Hopi, Navajo, Zuni, and Pueblo peoples.

Many roads lead to Chaco Canyon, both ancient and modern. Those that don't appear to have used it as a compass point. It is a crossroads of converging spirits, trails, and cultures. When essayist and novelist Frank Waters visited Chaco many

years before my own first visit, the Hopi told him the Flute Clan and Snake Clan came here during their storied migrations. High above Pueblo Bonito beyond the edge of the rimrock, the cliff-top dwellings of Pueblo Alto were built with a commanding view of Chaco Canyon and the surrounding landscape. Nearby, Waters's guide John Lansa showed him three sacred stone shrines called *Pohoki* ("prayer standing house") that formed a sun shrine. It marked the ceremonial race track the Flute Clan used, one "that extended northward to the sun temple at Mesa Verde, some three or four days' travel by foot." In its ceremonies, the Flute Clan was said to use the feathers and bones of macaws and other tropical birds that came from the south, perhaps from as far as the Mayan pyramids of the Yucatán jungle. These precious goods were bartered at the great Mesoamerican trade crossroads of Paquimé, or *Casas Grandes,* "Great Houses," in what is now Chihuahua, Mexico. Some archaeologists believe that the Chaco people built their own pueblos and "great houses" along alignments that traced a straight line paralleling the 108th Meridian, (107N 57'W), linking the multistory dwellings of Aztec in the north with Casas Grandes five hundred miles south.

My own road north to Chaco was not nearly as direct. I traced many highways, dirt roads, trails, and stony paths across New Mexico to witness daybreak at Fajada Butte. There were many forks and detours. Each demanded its own time line, proffered its own symbol, presented its own distinct marker, and carried its own legend: There were Spanish *caminos, jornadas,* and *entradas;* Old West trails, wagon routes, outlaw trails, and war trails; and literary and artistic paths and sojourns. Together they enticed me across a landscape of crimson deserts, mysterious ruins, lofty mesas, and snow-blessed mountains I hadn't seen before. Many were—and remain—like no place on earth. When Willa Cather wrote her novel on New Mexico Territory in 1927, *Death Comes for the Archbishop,* she described my own feelings that surfaced while tracing echoes of the past across New Mexico's beloved land to reach Chaco: They "whispered to the ear on the pillow, lightened the heart, softly picked the lock, slid

the bolts, and released the prisoned spirit of man into the wind, into the blue and gold, into the morning, into the morning."

Among the luminous landscapes that touched my spirit: White Sands glimmered at twilight with pearl, rose-tinted dunes. Rio Grande Gorge yawned beneath my feet through the earth's crust. El Santuario de Chimayó counted me among its pilgrims who had journeyed to its sacred shrine. El Camino Real de Tierra Adentro, "The Royal Road of the Interior Land," bustled with life that gave birth to modern "New Mexico." The Bootheel country sat alone and empty, luring me deeper into a corner of time once fought for by the Mexican revolutionary Francisco "Pancho" Villa. The wilds of the upper Gila River whispered of ancient Mogollon cliff dwellers, Geronimo's childhood, Ben Lilly's baying lion hounds, and snow falling on America's first wilderness area. It was a chain of journeys, impressions, emotions, and insights that led me from City of Rocks, Lake Valley, Sierra del Olvido, Jornada del Muerto, Valley of Fires, Bosque del Apache, Gran Quivira, Santa Fé, Bandelier, Taos, El Malpaís, El Morro, and finally to Chaco, what the Hopi called *Yupkoyvi,* "the place beyond the horizon."

Throughout my last memorable afternoon at Chaco, I wandered alone "beyond the horizon" along sandy paths that threaded the roofless rooms, kivas, and walls of its "great houses." Many bore the names of indigenous people who have viewed Chaco as sacrosanct to their culture. The Acoma described the setting of Chaco as *W'aasrba shak'a,* "place of greasewood." Hungo Pavi derived its name from Shongopovi, "Reed Spring Village," the distant Hopi village on Second Mesa in Arizona. Pueblo Bonito's fragile walls were called *Tsébiyaanii' áhá,* "leaping rock gap," by the Diné/Navajo. And most curious of all, each of the popular Pueblo names were rooted in the Spanish, not in the native languages of the indigenous ancestors who built them.

As sun fell behind the southwestern rim of Chaco Canyon, a shadow crept across the landscape. With it came winter chill and the promise of darkness. So I returned

to my campsite at the foot of a cliff in an arroyo named after a rooster. "I've got the place to myself," I thought. The elk I'd seen browsing on the rimrock above my camp the day before were gone. The coyote that sauntered through camp was nowhere in sight. The campground host—well, I guess it was me. In the fading light, I built a small campfire and watched the yellow flames cast shadows and light across the cliff walls. A one-room dwelling was tucked in the dark alcove beneath. It stood alone. There were no kivas, no second or third stories, no solstice or celestial markers that I could discern, no stylized masonry. It is not the Pantheon or Colosseum of the Old World that author Emma C. Hardacre compared Pueblo Bonito to in 1878. It was a simple adobe, room enough for a small family, a sacred hearth that offered refuge.

Spooning steaming menudo from the hot tin can boiling on the red coals of my piñon wood fire, the adobe reminded me of nearly every *paraje,* "rest stop," I made along the myriad caminos of Spaniards, Native Americans, Mexicans, and Anglos I traced to reach Chaco Canyon: "The story of my people and the story of this place are one single story," Pueblo elder Juan de Jesús Romero said long ago. "No man can think of us without thinking of this place. We are always joined together."

The story of New Mexico's places, and the story of its people, are one single story. No one can think of one without thinking of the other. They are always joined together.

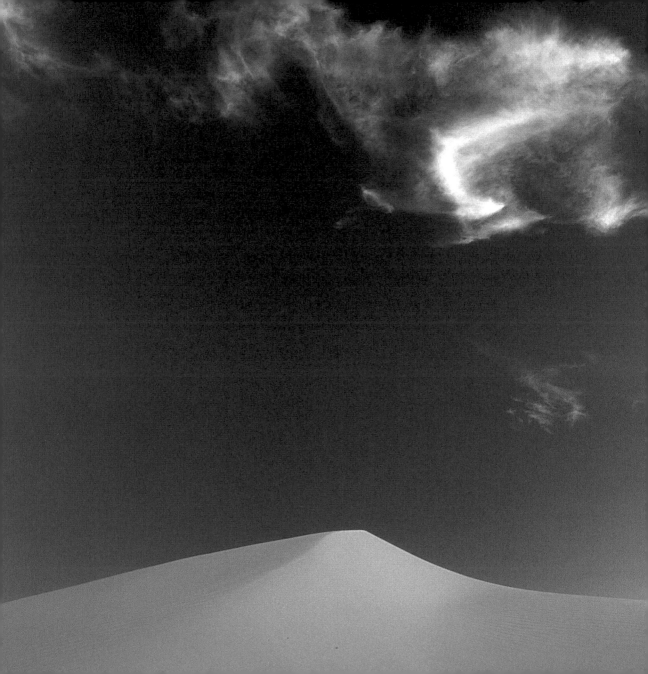

Living landscape, White Sands

"It was beauty, beauty absolute, at any hour of the day: whether the perfect clarity of morning, or the mountains beyond the simmering desert at noon, or the purple lumping of northern mounds under a red sun at night. . . . It was always beauty, *always!* . . . So it was, when you watched the vast and living landscape. The landscape lived, and lived as the world of the gods, unsullied and unconcerned. The great circling landscape lived its own life."

—D. H. Lawrence, 1925, *St. Mawr*

3

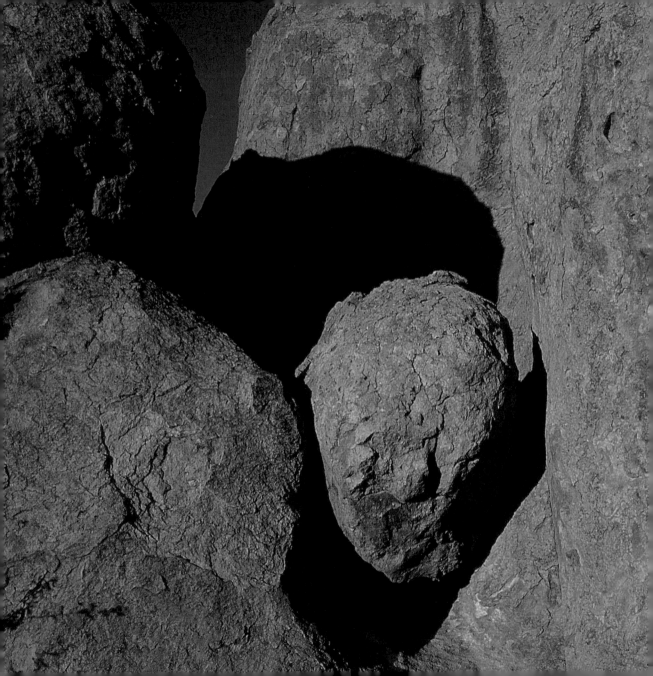

Pour Over, City of Rocks

"The lonely desert mesas stretched to a line of mountains etched on the stark blue horizon.... In the magnificent fierce morning of New Mexico one sprang awake, a new part of the soul woke up suddenly, and the old world gave way to a new."

—D. H. Lawrence, 1928, "New Mexico"

5

"White sands has come to life. The sun is on its rapid way to the west. The sand, no longer dull brown, has turned to rose . . . now cast long purple shadows over the rose-colored earth . . . into a mellow, homelike whole, a contrast of rose and darkness and over all a golden glow."

—Gladys A. Reichard, 1934, *Spider Woman*

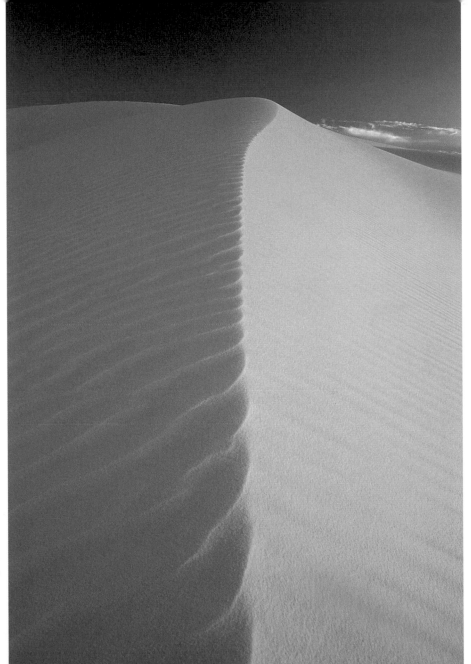

Shadow and light, White Sands

Pueblo Bonito, Chaco. *Pueblo Bonito,* "Beautiful Town"

"We have lived upon this land from days beyond history's record, far past any living memory, deep into the time of legend. The story of my people and the story of this place are one single story. No man can think of us without thinking of this place. We are always joined together."

—Juan de Jesús Romero, 1906, Pueblo spiritual elder

"Its very rocks are unique ...
astounding freaks of form
and color carved by the scant
rains and more liberal winds
of immemorial centuries, and
towering across the bare land
like the milestones of forgotten
giants."

—Charles F. Lummis, 1893,
The Land of Poco Tiempo

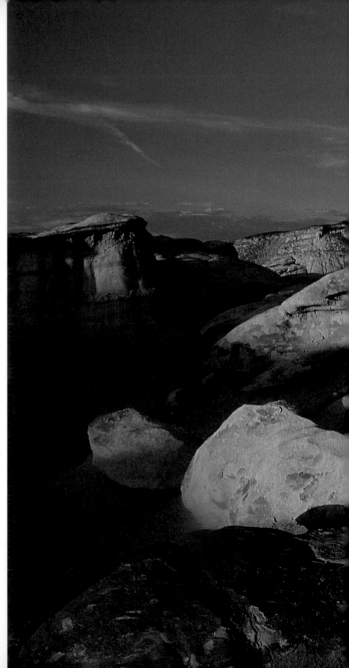

Hoodoos, Bisti Badlands. *Bistahí,* "among the adobe formations," Diné/Navajo

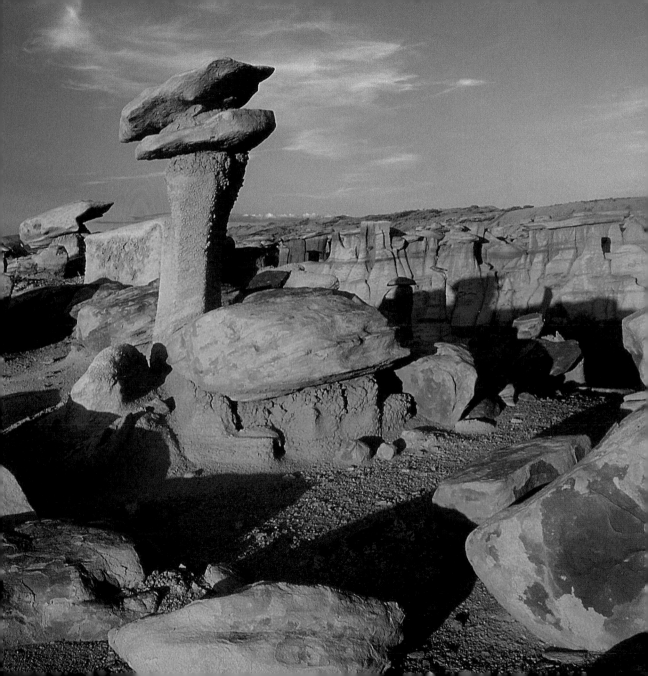

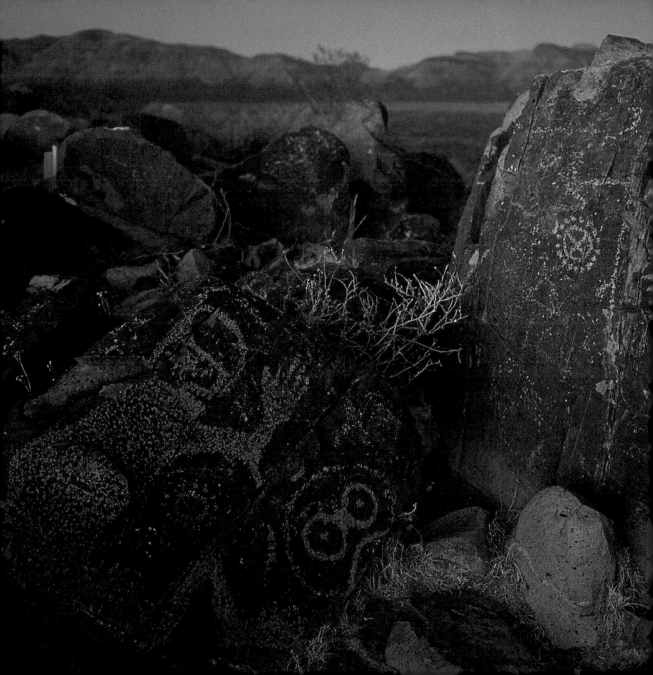

Story-teller rocks, Three Rivers

"Long before Cadmus invented letters, ... long before there were true historians or poets, there were fairy stories and story-tellers. And, today, if we would seek the place where fairy stories most flourish, we must go ... to peoples who have no books, no magazines, no alphabets—even no pictures. Of all the aboriginal peoples that remain in North America, none is richer in folk-lore than the Pueblo Indians of New Mexico."

—Charles F. Lummis, 1891,
The Man Who Married the Moon

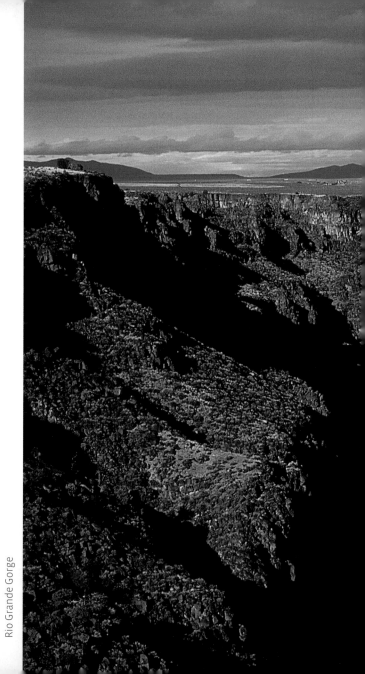

"This frightful chasm is absolutely impassable; and, viewed from the top, the scene is imposing in the extreme. None but the boldest hearts and firmest nerves can venture to its brink, and look down its almost perpendicular precipice, over projecting crags and deep crevices, upon the foaming current of the river, which, in some places, appears like a small rippling brook; while in others it winds its serpentine course silently but majestically along, through a narrow little valley; with immense plains bordering and expanding in every direction, yet so smooth and level that the course of the river is not perceived till within a few yards of the verge."

—Josiah Gregg, 1831–1839,
Commerce of the Prairies

Rio Grande Gorge

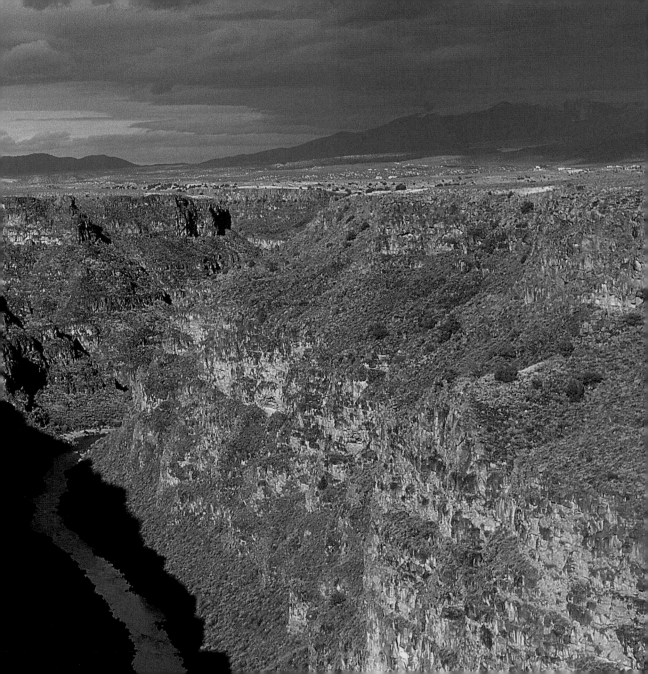

"Atención Gringo. For Gold & Glory, Come South of the Border and Ride with Pancho Villa, El Liberator of México! Weekly Payments in Gold to Dynamiters, Machine Gunners, Railroaders. Enlistments Taken in Juárez, México. Viva Villa! Viva Revolución!"

—Anonymous, January 1915, recruitment poster

Continental Divide, Bootheel Country

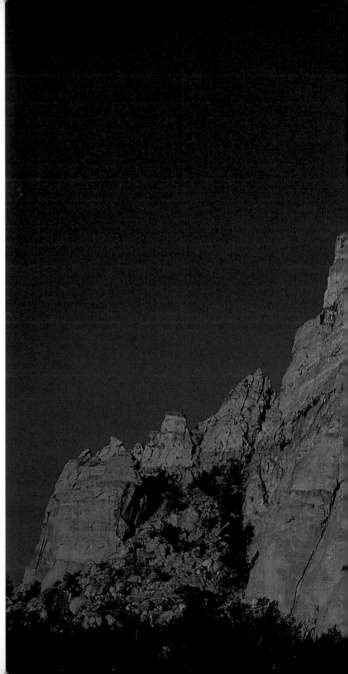

"We reached the old wolf in time to watch a fierce green fire dying in her eyes. I realized then, and have known ever since, that there was something new to me in those eyes— something known only to her and to the mountain. I was young then, and full of trigger-itch; I thought that because fewer wolves meant more deer, that no wolves would mean hunters' paradise. But after seeing the green fire die, I sensed that neither the wolf nor the mountain agreed with such a view."

—Aldo Leopold, 1949,
A Sand County Almanac

Mystery Mountain

18

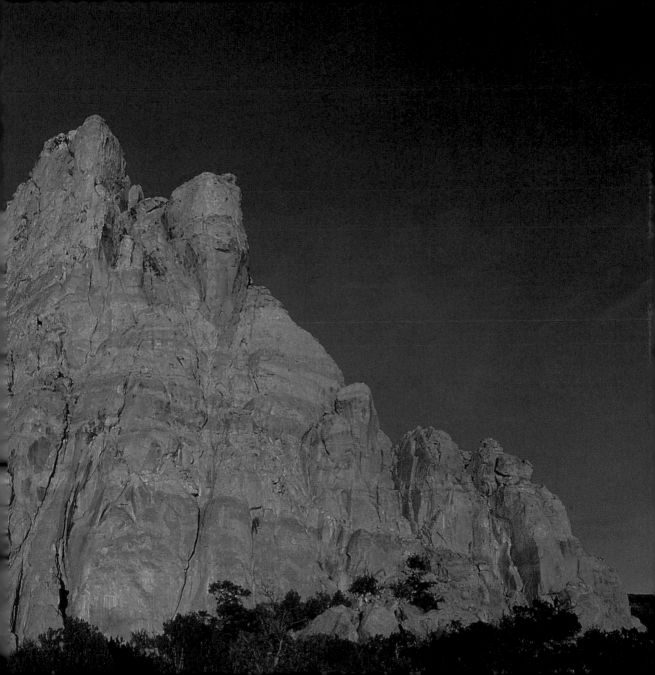

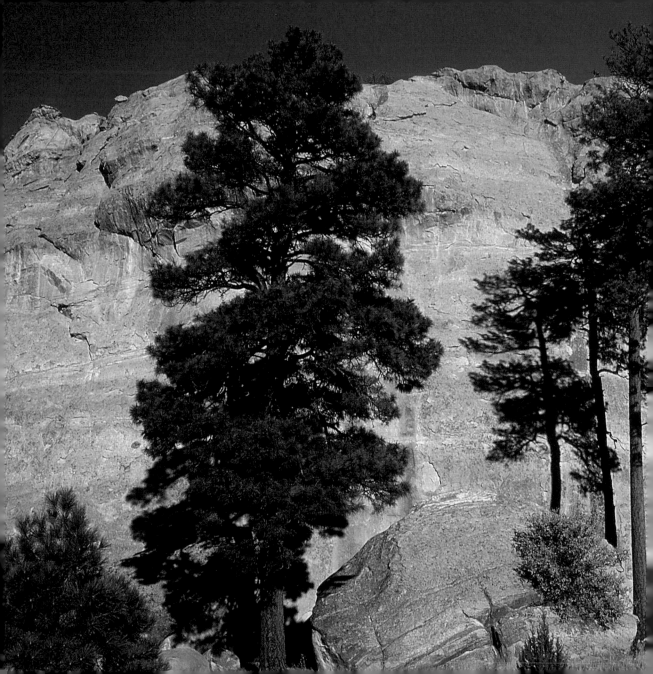

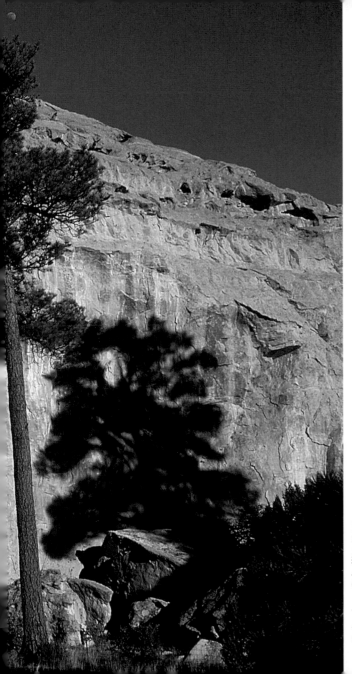

Twin pines, Cebollita Mesa

"They crossed a high plateau with somber cones of extinct volcanoes, crowding between rivers of block rock along its rim. Northward a wilderness of pines guarded the mesa; dark junipers, each one with a secret look, browsed wide apart. They thickened in the cañons from which arose the white bastions of the rock."

—Mary Austin, 1918,
The Trail Book

"There was no record but memory and it became tradition and then legend and then religion. So long ago that they did not know themselves how long, their ancestors, the ancient people, moved. They went with the weather. Seasons, generations, centuries went by as each brought discovery of places farther toward the morning."

—Paul Horgan, 1954,
Great River

Sunset, Río Grande, El Camino Real de Tierra Adentro

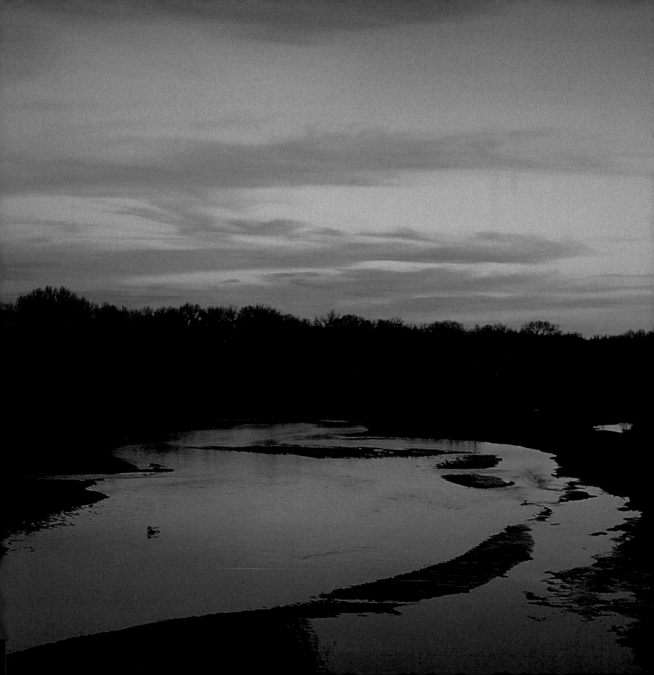

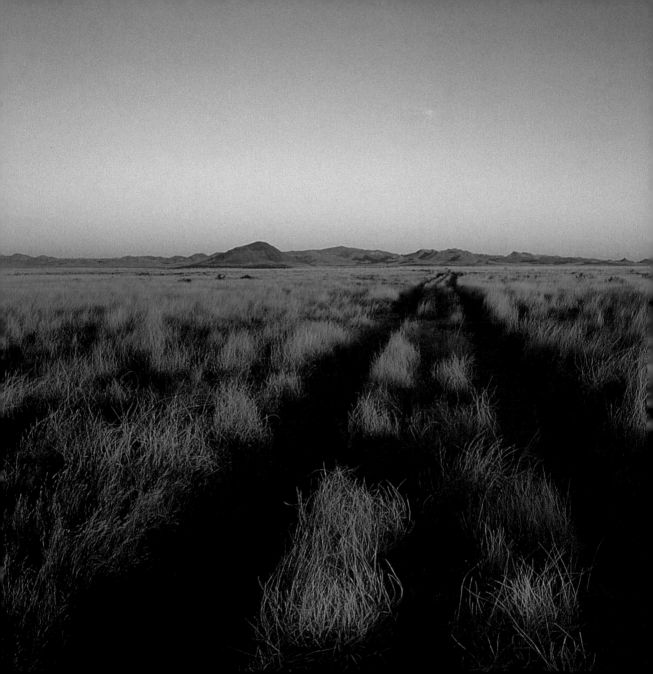

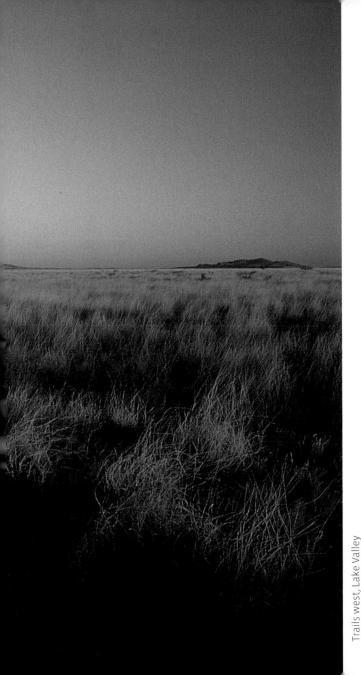

"It was noon when we got there and that night there was the hardest rain that I ever saw fall. The thunder and lightning was terrible and we were all scared to death. The water rose to the hubs of our wagon wheels and we thought we would be washed away at any minute.... We stayed here two months and the men prospected for gold. While we were here a baby girl was born to Mrs. Irwin, one of the women in our crowd. We fixed her a bed under a big pine tree, of pine needles. We put her feather bed and some quilts on the pine needles and she was very comfortable. She named the little girl 'New Mexico.'"

—Mrs. Alice Roberts, 1873–74, prospector's wife

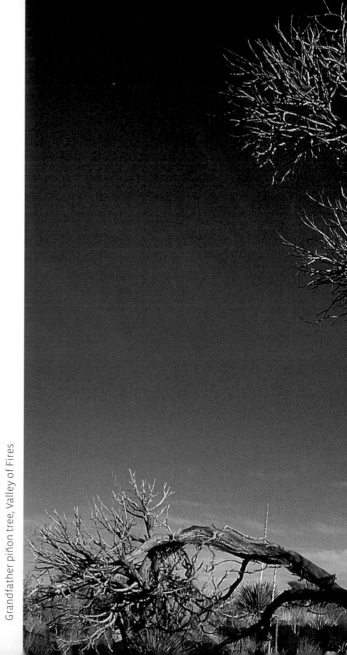

Out where the handclasp's a
little stronger,
Out where the smile dwells a
little longer,
That's where the West begins;
Out where the sun is a little
brighter,
Where the snows that fall are a
trifle whiter,
Where the bonds of home are a
wee bit tighter,
That's where the West begins.

Out where the skies are a trifle
bluer,
Out where friendship's a little
truer,
That's where the West begins;
Out where a fresher breeze is
blowing,
Where there's laughter in every
streamlet flowing,
Where there's more of reaping
and less of sowing,
That's where the West begins.

—Arthur Chapman, 1917,
Out Where the West Begins

Grandfather piñon tree, Valley of Fires

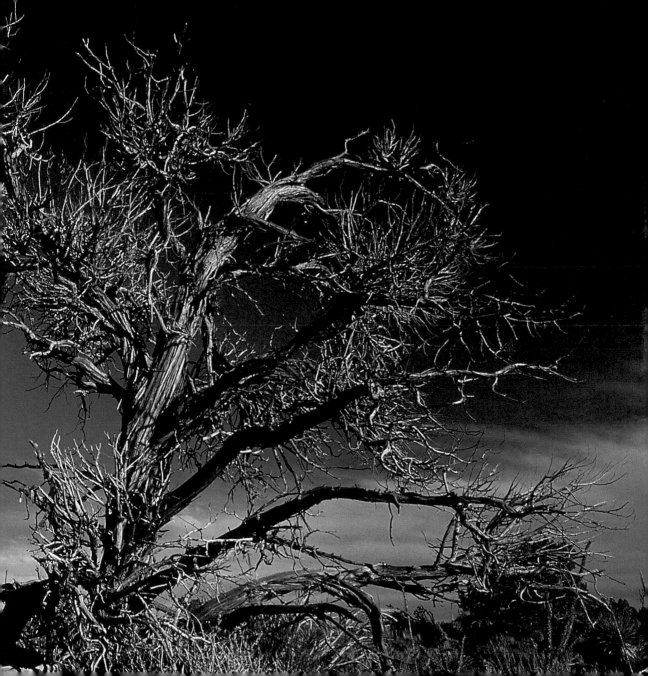

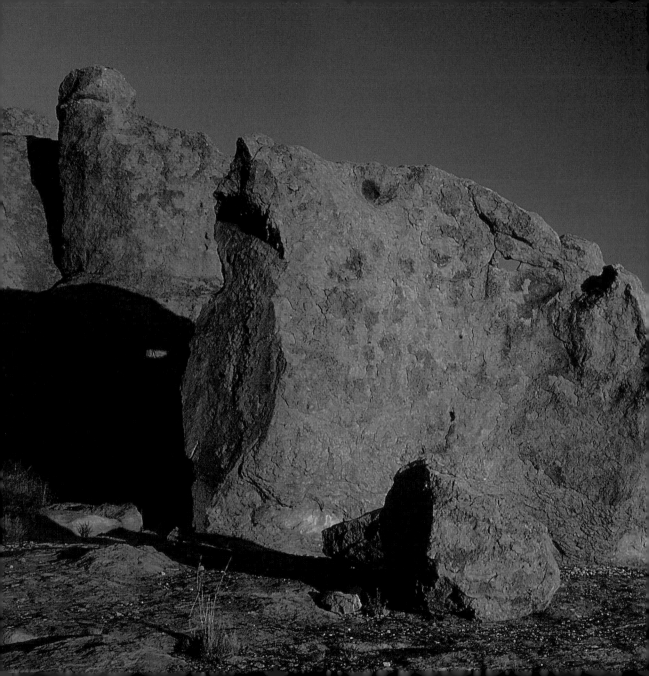

"You can't argue with those desert mountains and if you live among them enough—like the Indian does—you don't want to. They have something for us much more real."

—Maynard Dixon, 1875–1946

Peephole rock, City of Rocks

29

"Thousands of miles of
wilderness and desert we
trudged side by side—camped,
starved, shivered, learned. . . .
We went always by foot; my big
camera and glass plates in the
knapsack on my back, the heavy
tripod under my arm; [Bandelier
carrying] his aneroid surveying
instruments, and satchel of
the almost microscopic notes.
. . . Up and down pathless
cliffs, through tangled cañons,
fording icy streams and ankle-
deep sands, we travailed."

—Charles F. Lummis, 1890,
The Delight Makers

Frijole Falls, Bandelier

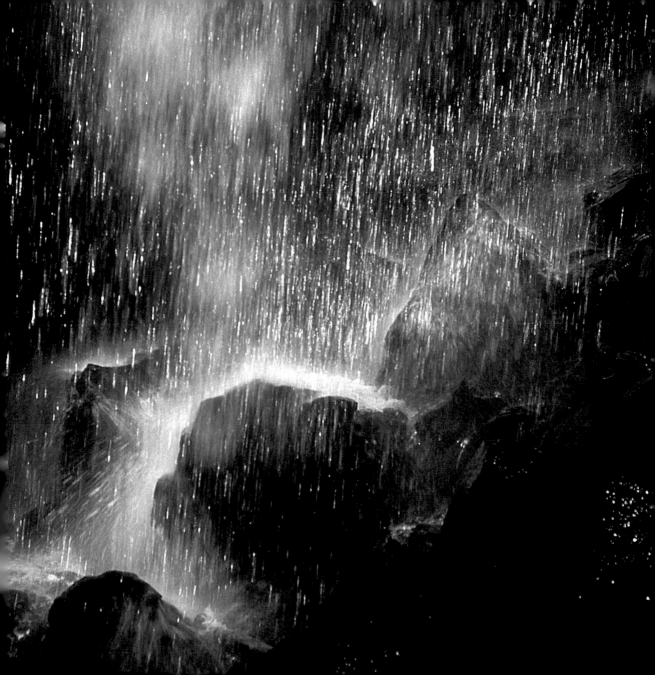

Morning snow, Zuni Plateau

"Along the sheer and noble northern cliff crumble the bones of a human past—a past of heroism and suffering and romance. In the foot of that stone snow-bank new shadows play hide and seek in strange old hollows, that were not gnawed by wind and rain, but by as patient man."

—Charles F. Lummis, 1893,
The Land of Poco Tiempo

33

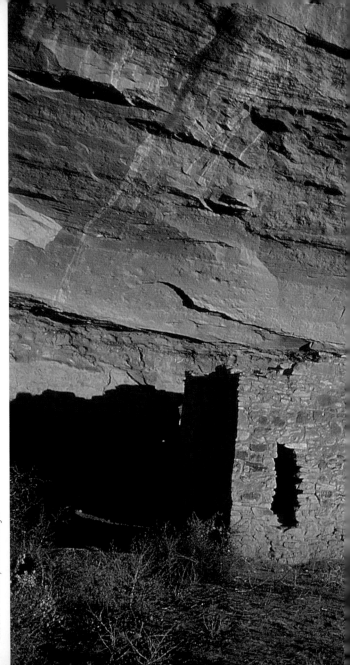

"We set out to reconstruct the life and times of the ancient people of the American Southwest. . . . It is not alone for the naturalist, the artist, the philosopher, nor for the Indian who is something of all these. It is for every mind that can see relations, for every spirit that is moved by harmonies of color and light and form. All must have, by this time, pictured its vast canyons, mountains, mesas and deserts, and acquired something of the sense of reverence for space and silence."

—Edgar L. Hewett, 1930, *Ancient Life in the American Southwest*

Casa de Alcove, Gallo Arroyo

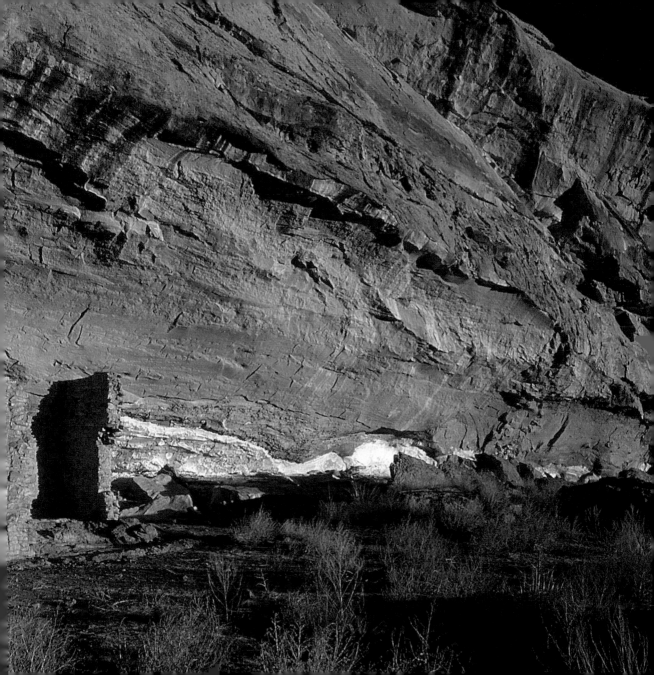

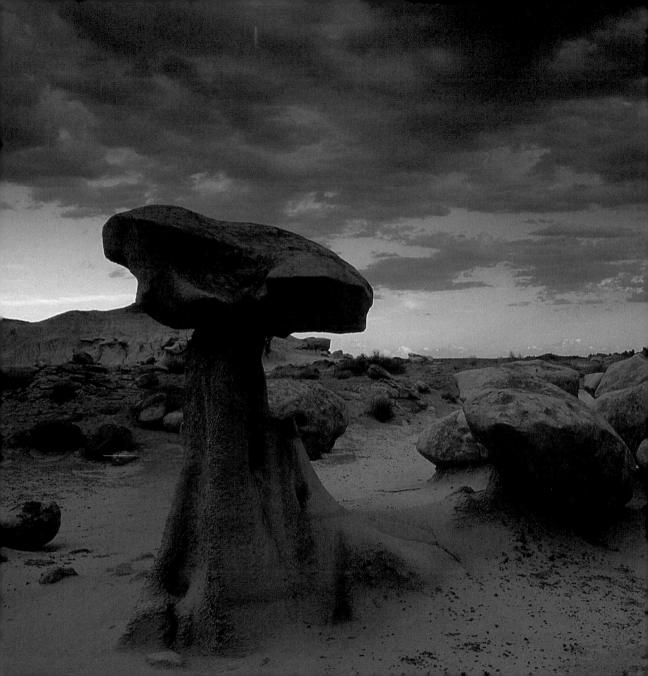

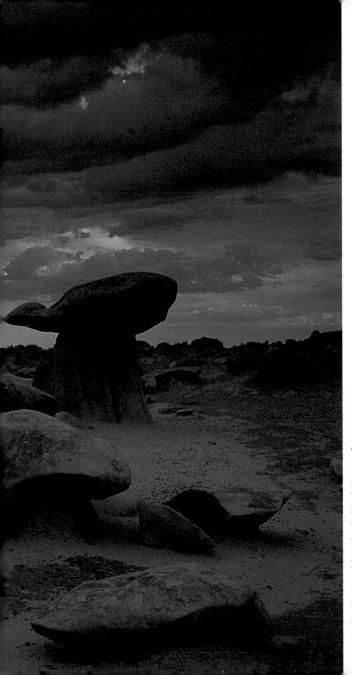

Badlands, Bistahí. *Malpaís*, "Bad Country"

"The first day the gods smiled on me, blessing me with luminous light that had earned this bewitching mile-country the name Land of Enchantment. The second day the clouds turned gray and blue, and doubts about re-entering the badlands crept in."

—John Annerino, 2006,
Desert Light

37

"It was near midnight and Pete was in bed. I walked to the head of the bed and sat down. . . . I asked him as to the whereabouts of [Billy] the Kid. He said that the Kid had certainly been about, but he did not know whether he had left or not. At that moment a man sprang quickly into the door. . . . He . . . held a revolver in his right hand and a butcher knife in his left.

"He came directly towards me . . . leaned both hands on the bed, his right hand almost touching my knee, and asked, in a low tone:— 'Who are they Pete?'—at the same instant Maxwell whispered to me, 'That's him!' [The Kid] raised his pistol, a self cocker, within a foot of my breast. Retreating rapidly across the room he cried: *'Quien es? Quien es?'* ('Who's that? Who's that?') All this occurred in a moment. Quickly as possible I drew my revolver and fired, threw my body aside, and fired again. The second shot was useless; the Kid fell dead. He never spoke. A struggle or two, a little strangling sound as he gasped for breath, and the Kid was with his many victims."

—Sheriff Pat Garrett, July 14, 1881, *The Authentic Life of Billy the Kid*

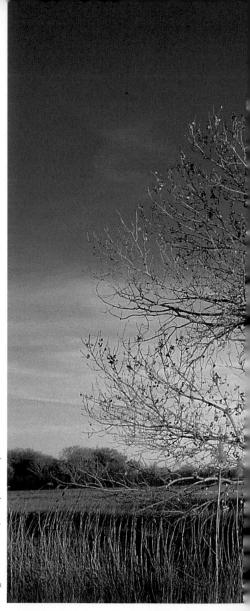

Fragile moments, Bosque del Apache

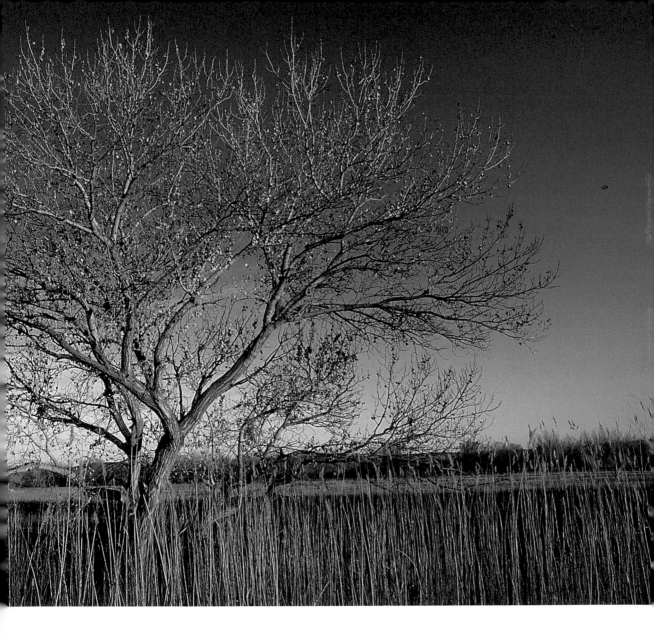

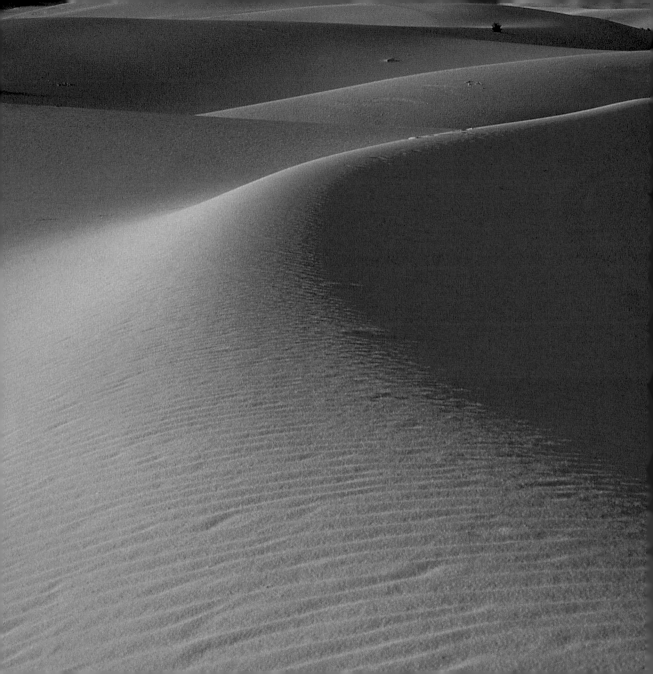

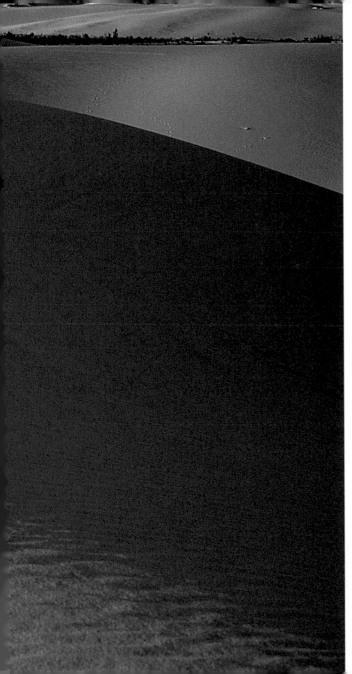

Ghost dunes, White Sands

"It is said that the ghost of this beautiful, Spanish maiden haunts the dunes of the Great White Sands. She comes nightly in her flowing, white wedding gown to seek her lover, lost and buried beneath the eternal dunes. Some say that the ghostly figure usually appears as the evening breezes sweep and dip over the stark white dunes, just after sunset."

—Anonymous,
"The Legend of Pavla Blanca"

"With the first gray arc of dawn that bit into the black mass of night, some of the Hopi elders climbed the kiva ladders and looked eagerly toward the four quarters of the Earth. Was the power of their ceremony working yet? Would the gods of the north send yellow-hued clouds filled with buoyant feathers of the snow? Would the Mongwi [Kachina spirit] of the southern realm speed to them red, flame-shot clouds of warm, abundant rain? With slow reluctance the sun stirred in the eastern sleep and wearily began his daytime labor of climbing to high zenith and then plodding to the limits of the west. The darkness brushed away."

—John Nelson, 1937,
Rhythm for Rain

First light, Chacra Mesa

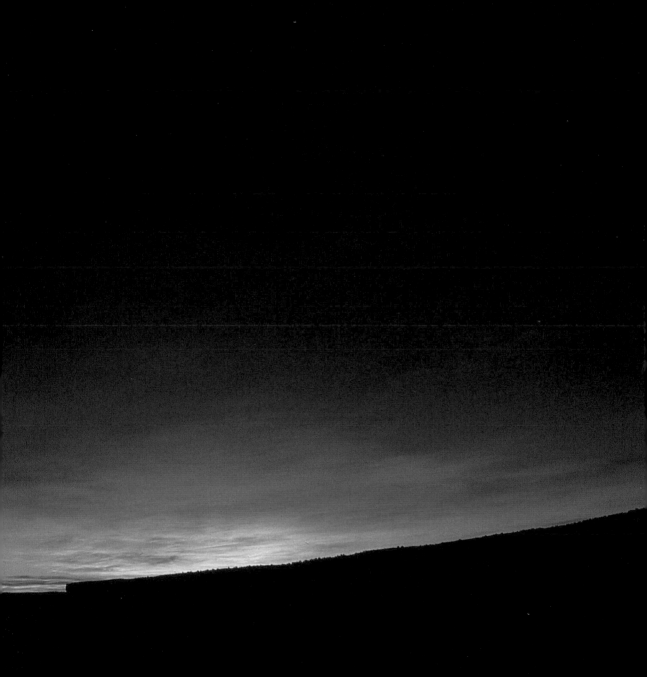

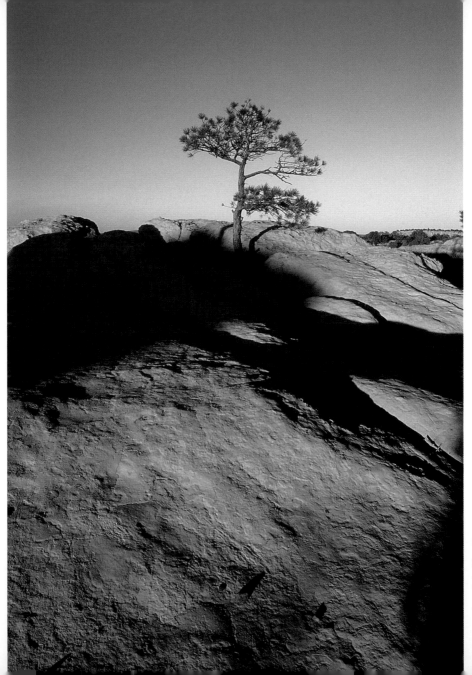

Lone pine, Cebollita Mesa

"Acts of creation are ordinarily reserved for gods and poets, but humbler folk may circumvent this restriction if they know how. To plant a pine, for example, one need be neither god nor poet; one need only own a good shovel."

—Aldo Leopold, 1949, *A Sand County Almanac*

"The figure of a hand with extended fingers is very common ... as a rock etching, and also is frequently seen daubed on the rocks with colored pigments or white clay. These are vestiges of a test formerly practiced by the young men who aspired for admission to the fraternity of the Calako. The Calako is a trinity of two women and a man from whom the Hopi obtained the first corn."

—Walter Hough, 1915,
The Hopi Indians

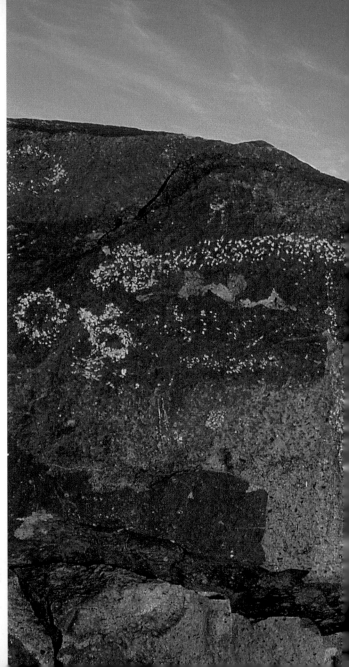

Hand petroglyph, Three Rivers

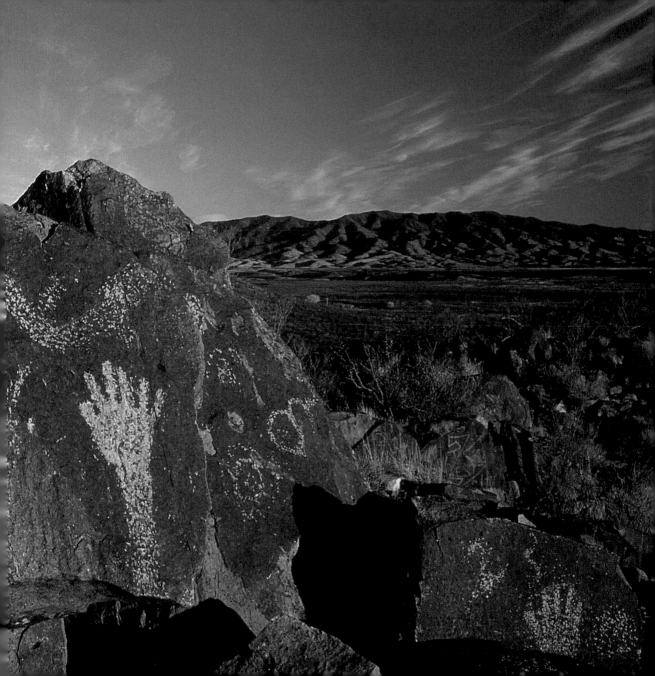

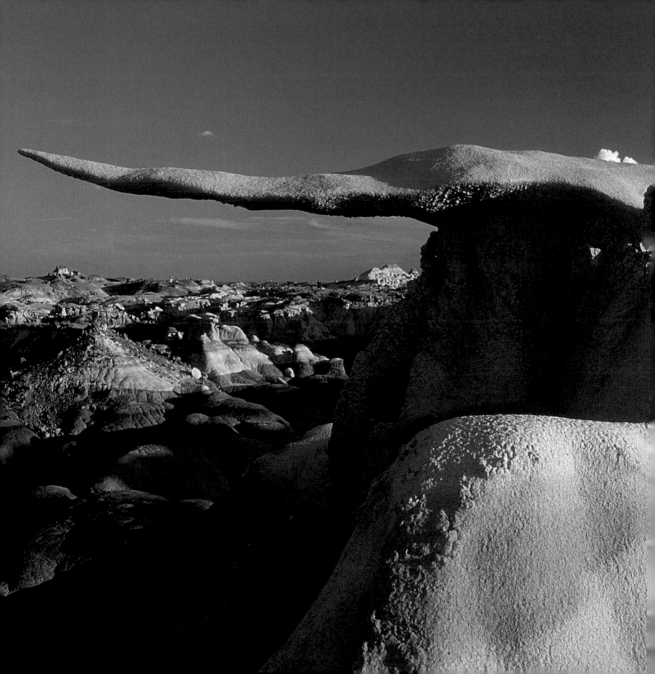

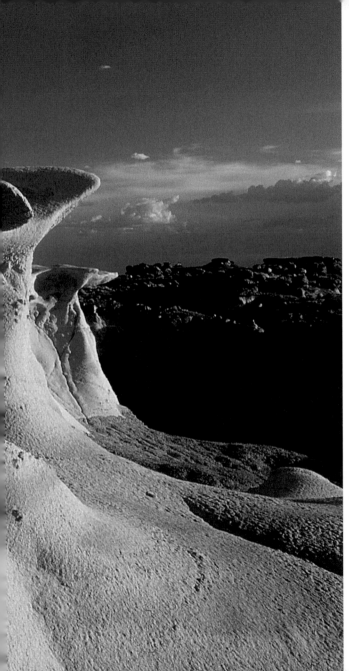

The Faraway, Bisti/De Na Zin

"Such a beautiful, untouched lonely feeling place, such a fine part of what I call the 'Faraway.' It is a place I have painted before ... even now I must do it again."

—Georgia O'Keeffe, 1941, correspondence

49

"The plateau country is not a smooth and level region, as its name might imply; it is extremely rugged, and the topographical obstacles to travel are greater than in many wild mountain regions. It is a country of cliffs and canyons. . . . There are mesas everywhere; it is the mesa country."

—Cosmos Mindeleff, 1897,
*The Cliff Ruins of
Canyon de Chelly*

Rimrock, El Malpaís

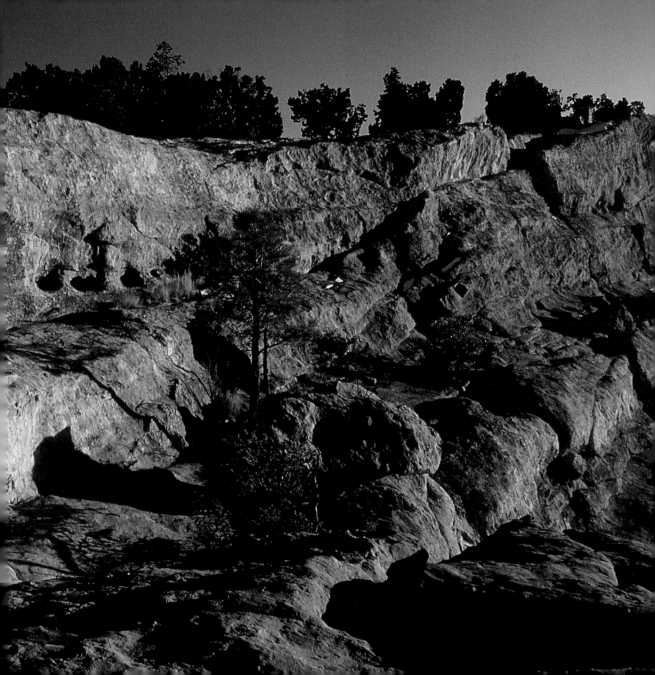

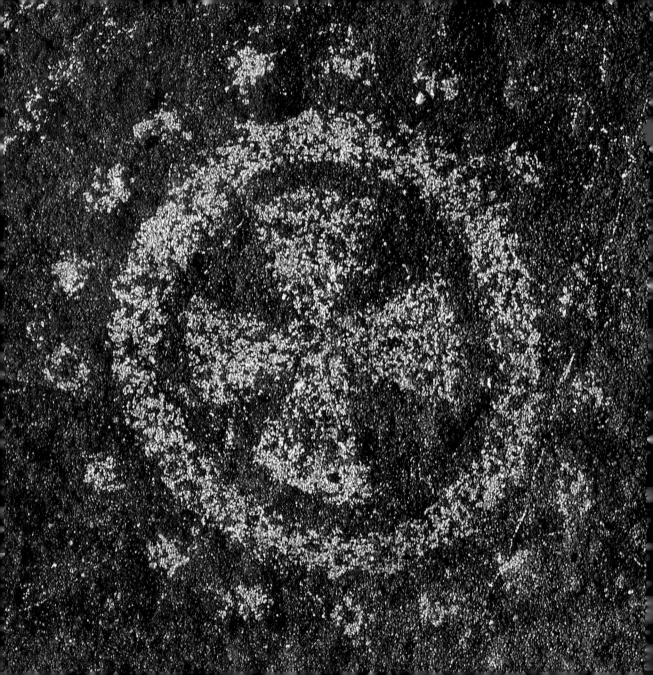

"Pictographs may have been messages, drawings for ceremonial purposes, or effusions of bad boys done for fun. They have not been fully deciphered, though various symbols of sun, moon, stars, rainbow, clouds, animals, and various clan symbols used today are found among them."

—Erna Furgusson, 1931, *Dancing Gods*

That, with their throats all
miserable dry,

The tender children, women,
and the men,

Afflicted, ruined, quite burnt up,

Did beg for aid from sovereign
God,

This being the final remedy

That they should have in such
distress.

And the sad, tired animals,

Feeble as those of Ninevah,

Worn down by the unchecked
fast,

This all did show themselves
worn out

By the weather they had
borne. . . . "God succored us
with a downpour

so heavy that very large pools
formed . . .

Therefore we name this place

Socorro del Cielo
[Help from Heaven].

—Don Juan de Oñate, 1598,
Jornada del Muerto,
"Journey of the Dead Man"

54

Old San Miguel Mission, Socorro. Misión de Nuestra Senora del Perpetuo, "Our Lady of Perpetual Help Mission

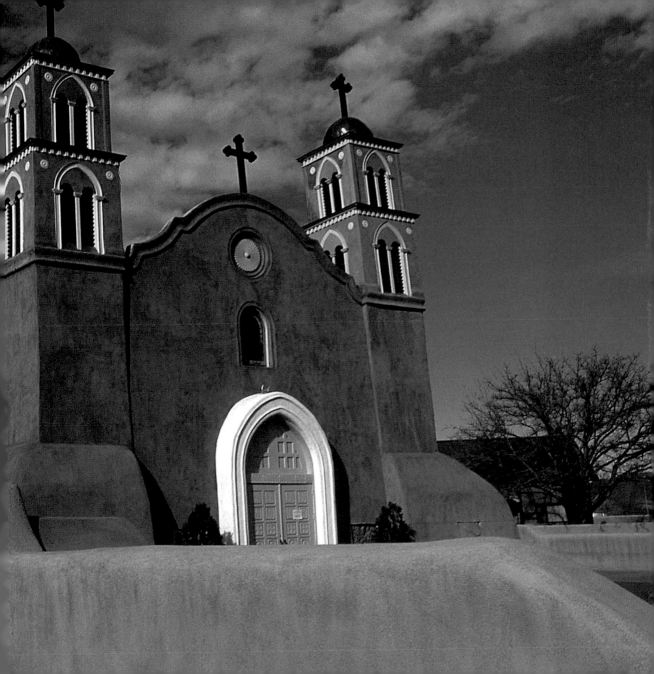

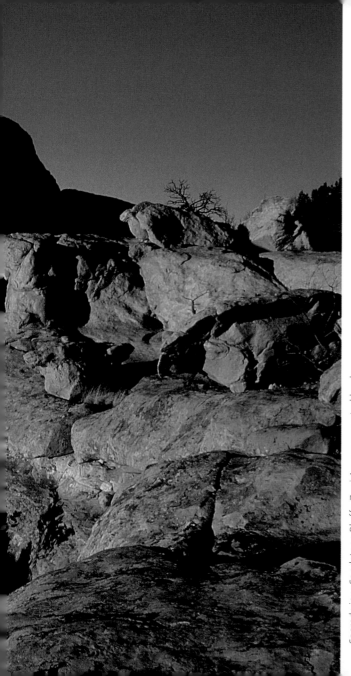

Sacred view, Sandstone Bluffs, Zuni-Acoma ancestral lands

"The Zuni view their universe
as a single complete whole.
All parts are equally important.
... The total landscape is their
religious universe.... 'The
world is their church.' The
entire world is sacred, but
certain portions, certain places
are especially sacred."

—Edmund Ladd, 1980,
"Pueblo Uses of High Altitude Areas"

"No other cliff on earth records a tithe as much of romance, adventure, heroism. Certainly all the other rocks in America do not, all together, hold so much of American history. Oñate here carved his entry with his dagger two years before an English speaking person had built a hut anywhere in the New World, and 15 years before Plymouth Rock."

<div align="right">—Charles F. Lummis, September 1, 1926, visitor register</div>

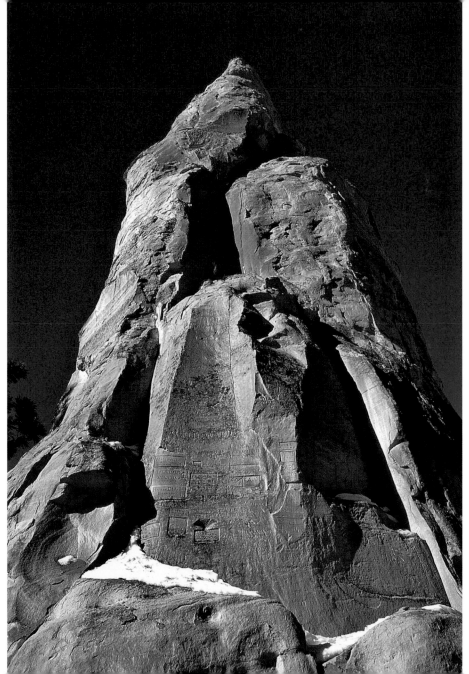

The Point, El Morro

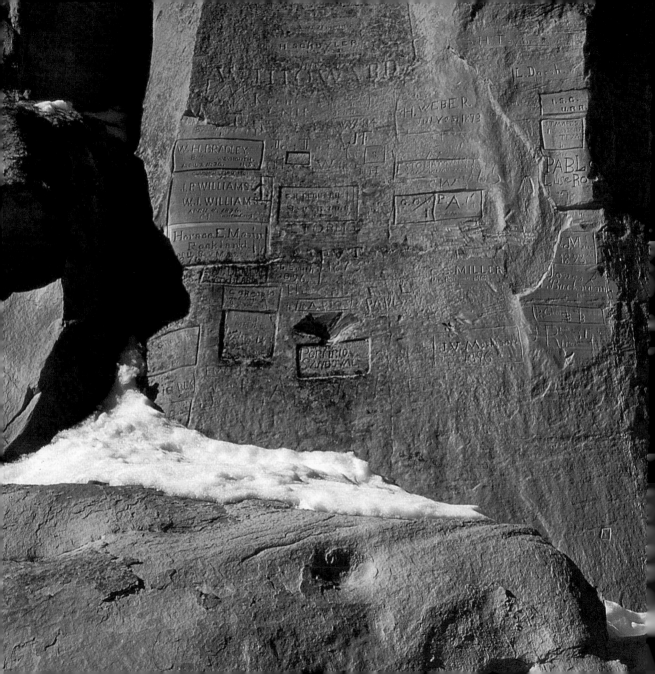

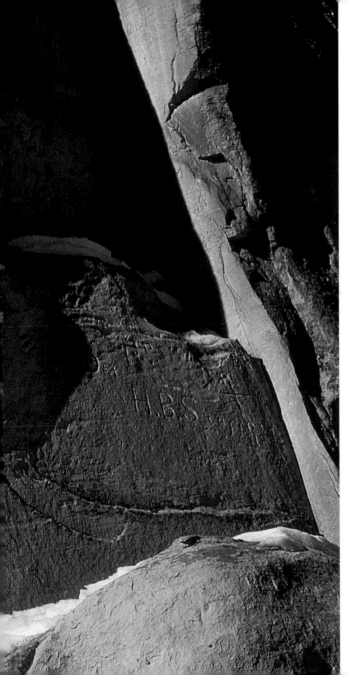

Inscription Rock, El Morro

"'El Morro, "the Castle," the Spaniards called it,' said the Road-Runner, casting himself along the laps of the trail like a feathered dart. 'But to our Ancients it was always "The Rock." On winter journeys they camped on the south side to get the sun, and in summers they took the shade on the north. They carved names and messages for those that were to come after, with flint knives, with swords and Spanish daggers. Men are all very much alike,' said the Road-Runner."

—Mary Austin, 1918,
The Trail Book

"Every day throughout the year, men, women, and children from all directions, from Colorado on the north to Chihuahua and Sonora on the south, may be seen approaching the shrine, in carriages, in wagons, on horses, or burros, or on foot; but all inspired with full faith in the supernatural remedial power that is here manifested, and high hopes that a good Providence will vouchsafe life and health to the suffering pilgrim. It is not a rare occurrence to see whole families coming in a commodious coach to bring some little one deformed from birth or injured by accident, whose case is beyond the curative power of the most skillful physician, and for whom the only hope is in the merciful interposition of supernatural power."

—L. Bradford Prince, 1915, *Spanish Mission Churches of New Mexico*

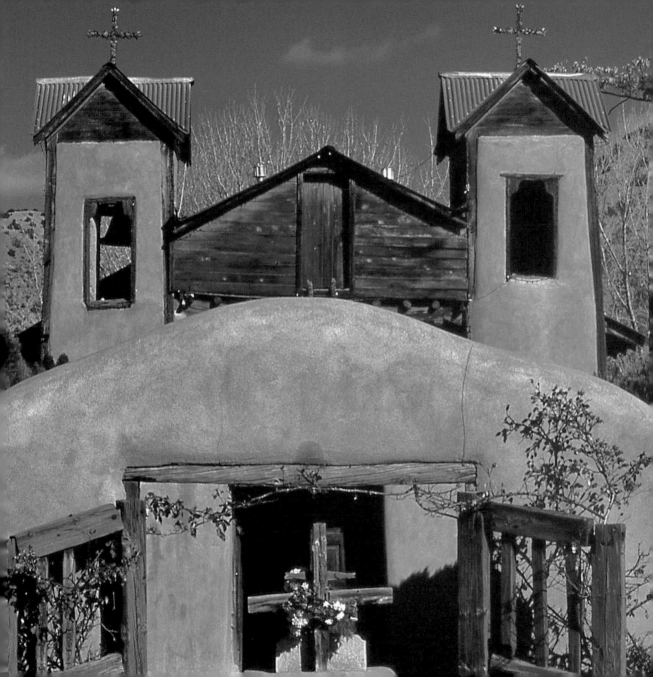

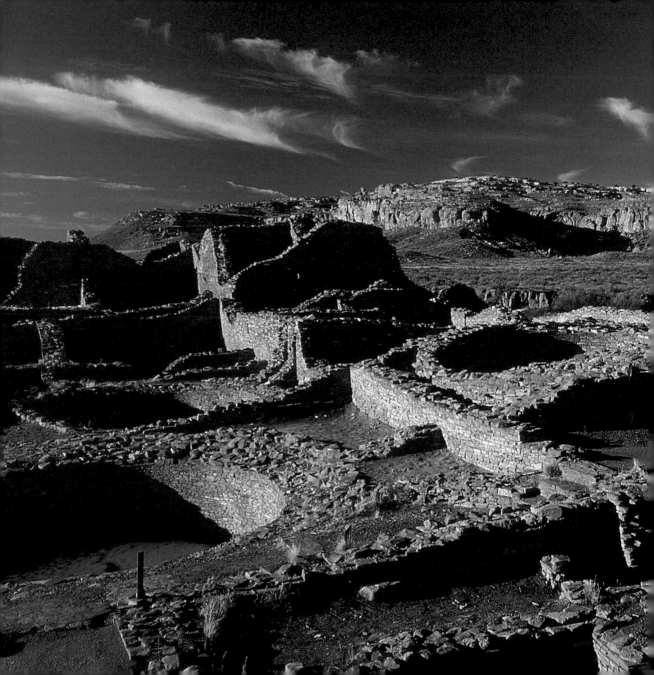

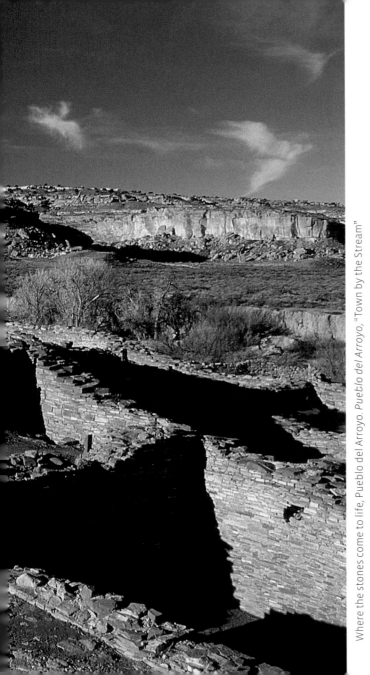

Where the stones come to life, Pueblo del Arroyo. *Pueblo del Arroyo,* "Town by the Stream"

"We are now to challenge this realm of silence to give up its secrets. We are to summon back the vanished generations, and bid them enact for us the drama of their years, the tragedy of their ending. We are to clothe the bleaching bones of dead towns with new flesh and animate anew a race of men. If the archaeologist can not resurrect the sleeping past, cause the embers of ancient life to glow again, he has dug to no purpose. This is the domain of pure archaeology, the realm of the pick and spade, the place, in another of the fine phrases of [Charles F.] Lummis, 'where the stones come to life.'"

—Edgar L. Hewett, 1930,
*Ancient Life in the
American Southwest*

"The colonel said, 'Someone needs to do Fajada Butte,' and there it was in the distance. There was an experienced climber—Jay Crotty—who was ready to go. . . . I said, 'I'll go,' and we climbed the butte and recorded about twenty-two [archaeological] sites, not quite to the top, but near. We decided to climb to the top that first afternoon and see what was there. We saw a beautiful, carved spiral in the shadow of three leaning large rock slabs . . . and a dagger of light was bisecting the spiral. It was formed by one of the openings of the three rock slabs in front of the spiral. I felt certain it was marking the summer solstice because the sharply pointed light shaft centered on the spiral created such a strong image."

—Anna Sofaer, June 29, 1977, Fajada Butte "sun dagger" discovery

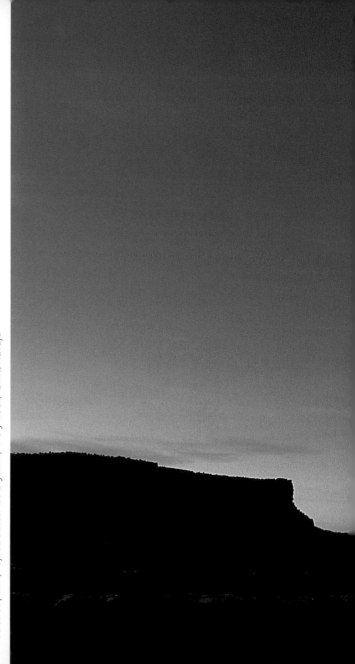

Solstice point, Fajada Butte. *Tsé Diyinnii,* "Holy Rock," Diné/Navajo

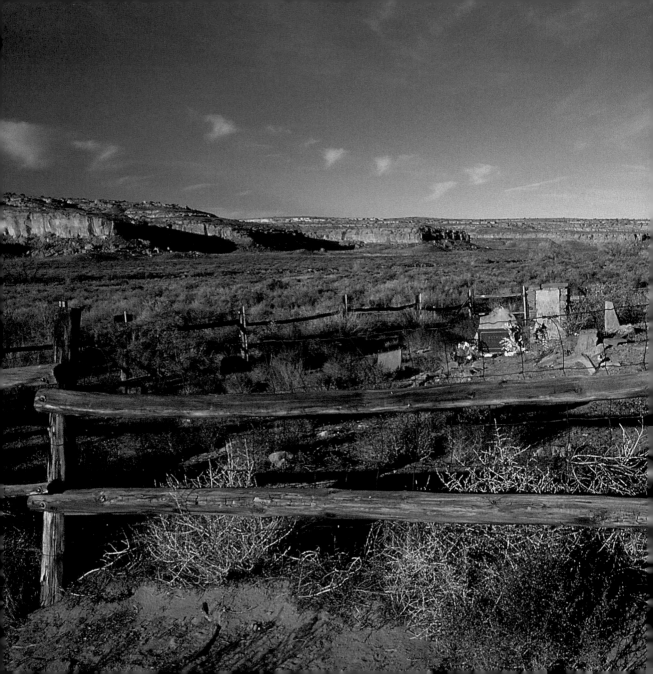

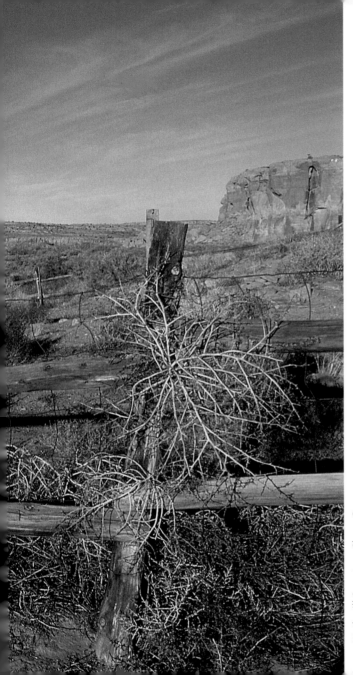

Wetherill Cemetery, Chaco Canyon

"Marrieta was only twenty years old and Richard [Wetherill] was thirty-eight when he brought her back to Chaco Canyon in the spring of 1897. After a honeymoon in the cold wilderness of Grand Gulch the girl's first home as Richard's wife was a wall tent under the high cliff back of Pueblo Bonito."

—Frank McNitt, 1966,
Richard Wetherill: Anasazi.
Pioneer Explorer of
Southwestern Ruins

69

My mother gave me to the moons,
And gave in turn the moons to me,
One midnight when she sang her tunes
 To a baby on her knee.

I saw a kingdom in the sky;
And as I watched it move and shine,
I stretched my arms out with a cry,
 Knowing the moon was mine.

Though I have seen the right turn wrong,
And common things grow strange,
O I have watched the moons too long
 To be afraid of change.

—Haniel Long, 1920, "The Conspiracy"

Moonrise, Taos Plateau

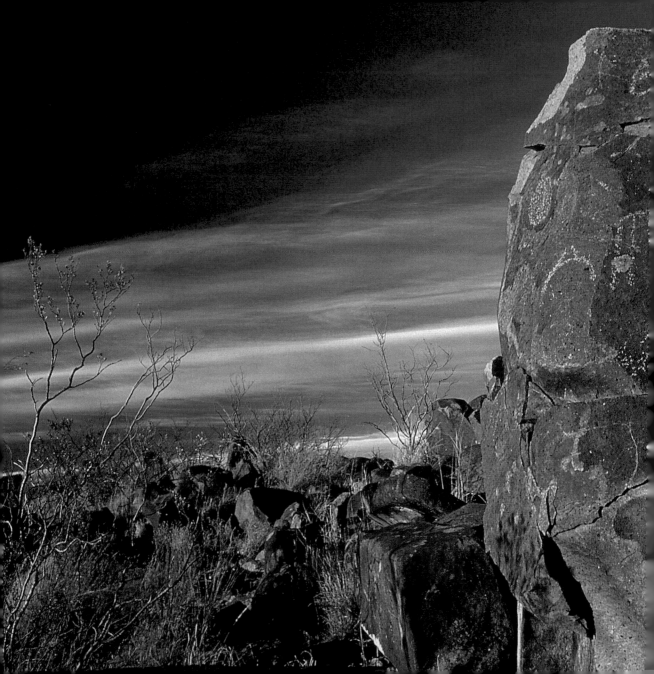

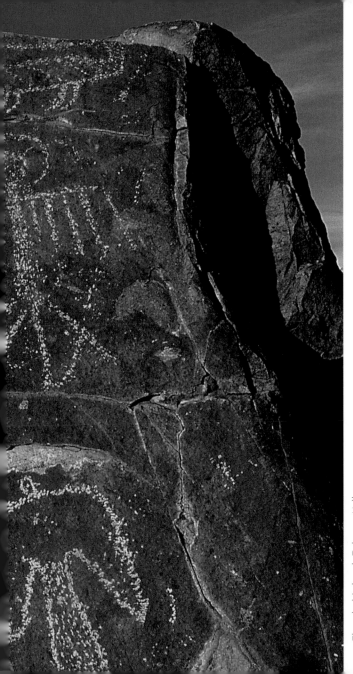

Thunderbird rock, Tularosa Valley

"These Thunderbirds are part of the Great Spirit. Theirs is about the greatest power in the whole universe. It is the power of the hot and the cold clashing above the clouds. It is the blue lightning from the sun. . . . The thunder power protects and destroys. It is good and bad; the great winged power."

—John Lamedeer, 1973,
Lame Deer, Seeker of Visions

"The first season's party [of archaeologists] pitched its tents on the adobe flat before the famous ruin early in May 1921, improvised for its kitchen stove an altogether inadequate shelter from spring sandstorms, dug a well in the nearby arroyo, and went to work.... Our crew of Zuñi and Navaho workmen varied.... Contrary to the predictions of one alarmist, we experienced no trouble from the simultaneous employment of representatives from these two tribes, hereditary enemies for over 400 years. So far as I could observe, the Zuñi were always welcome guests at Navaho homes throughout the valley, and several Navaho were invariably present on Sunday nights when the Zuñi danced and sang in the light of a weekly bonfire in front of our tents."

—Neil M. Judd, 1950, *The Material Culture of Pueblo Bonito*

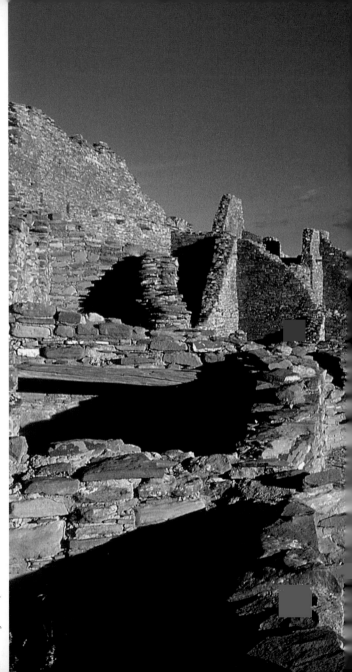

Daybreak, Pueblo Bonito

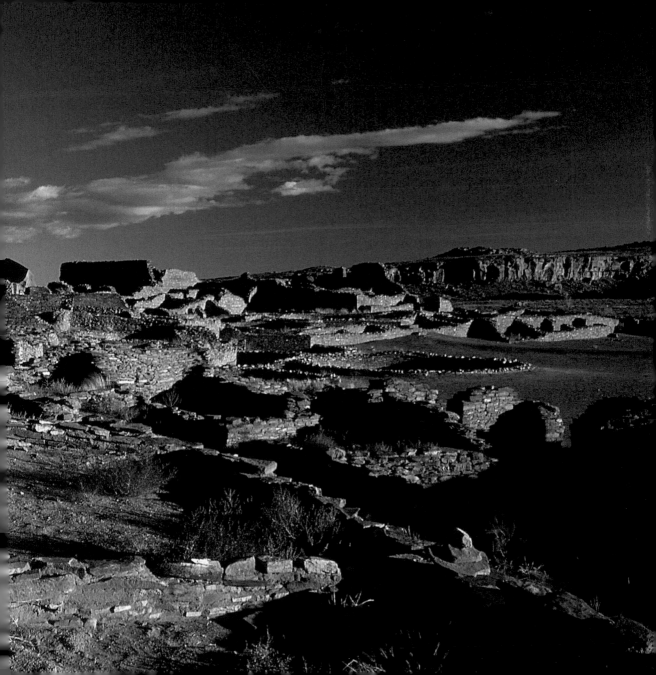

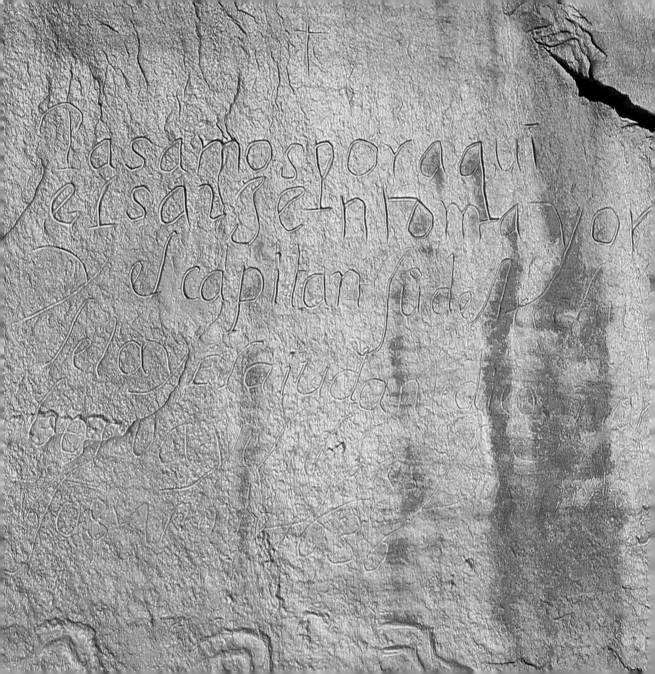

"Pasamos por aqui el Sarjento mayor y
el Capitan Ju[an] de Arechuleta y el
Aiudante Diego Martín Barba y el alferes
Agustin de Ynojos año de 1636.
"We passed by here, the Sergeant mayor and
the Captain Ju[an] de Arechuleta and the
Adjutant Diego Martín Barba and the ensign
Agustin de Ynojos year of 1636."

—Captain Juan de Arechuleta, 1636, *El Morro*

"But alas for Hidden Water and the army of sheep!—in this barren Winter the torrential rains did not fall, the grass did not sprout, and the flowers did not bloom. A bleak north wind came down from the mountains, cold and dry and crackling with electricity, and when it had blown its stint it died down in a freezing, dusty silence."

—Dane Coolidge, 1910,
Hidden Water

Frozen silence, Bosque del Apache

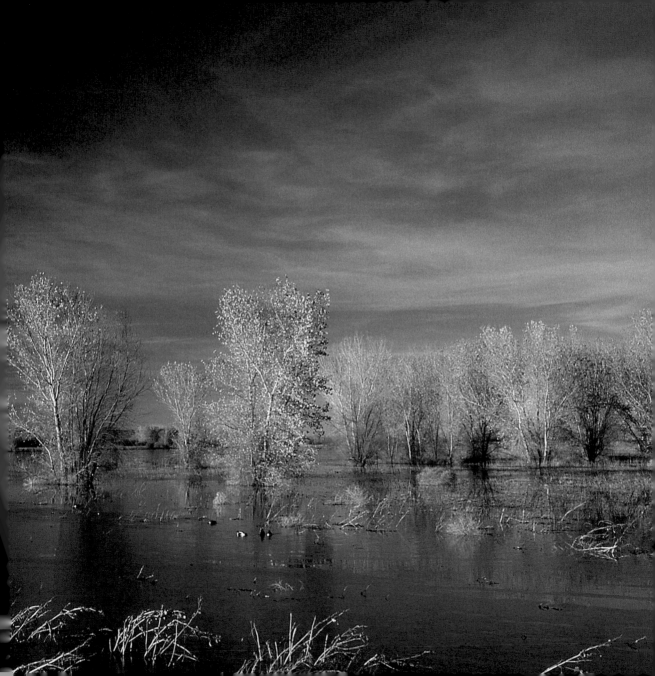

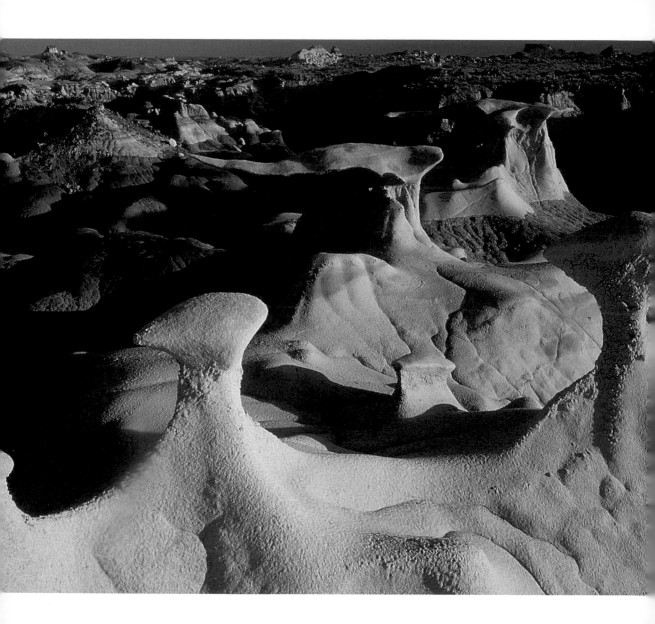

Goblins, Bisti Desert

"The Spanish Fathers who came up to Zuñi, then went north to the Navajos, west to the Hopis, east to all the pueblos scattered between Albuquerque and Taos, they came into a hostile country, carrying little provisionment but their breviary and crucifix. . . . A European could scarcely imagine such hardships. . . . But in the alkali deserts the water holes were poisonous, and the vegetation offered nothing to a starving man. Everything was dry, prickly, sharp; Spanish bayonet, juniper, greasewood, cactus; the lizard, the rattlesnake,—and man made cruel by a cruel life. Those early missionaries threw themselves naked upon the hard heart of a country that was calculated to try the endurance of giants. They thirsted in its deserts, starved among its rocks, climbed up and down its terrible canyons on stone-bruised feet, broke long fasts by unclean and repugnant food. Surely these endured Hunger, Thirst, Cold, Nakedness, of a kind beyond any conception St. Paul and his brethren could have had."

—Willa Cather, 1927, *Death Comes for the Archbishop*

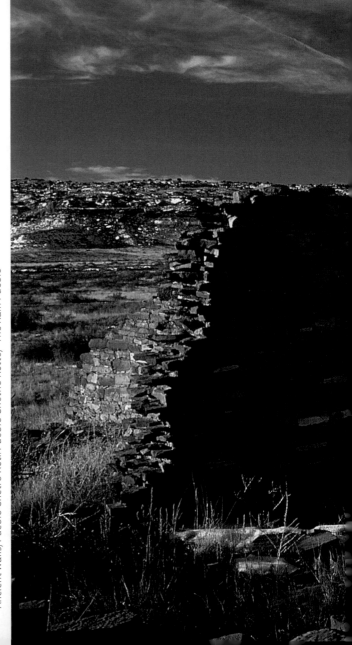

"Chaco Canyon . . . was abandoned a hundred years or so before the Great Drought; yet its masonry is unsurpassed; it represents the highest stage that Pueblo culture ever reached."

—Erna Furgusson, 1940,
Our Southwest

Ancient walls, Pueblo Chetro Ketl. *Pueblo Chetro Kette,* "The Rain Pueblo"

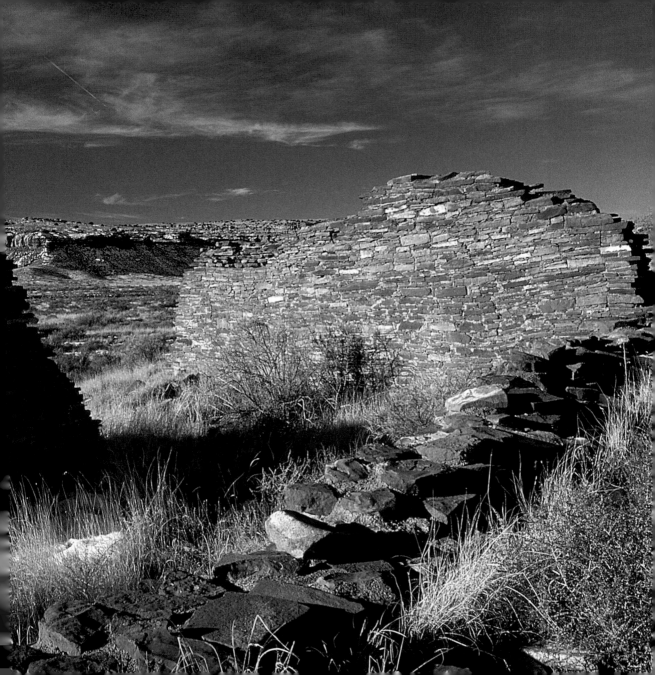

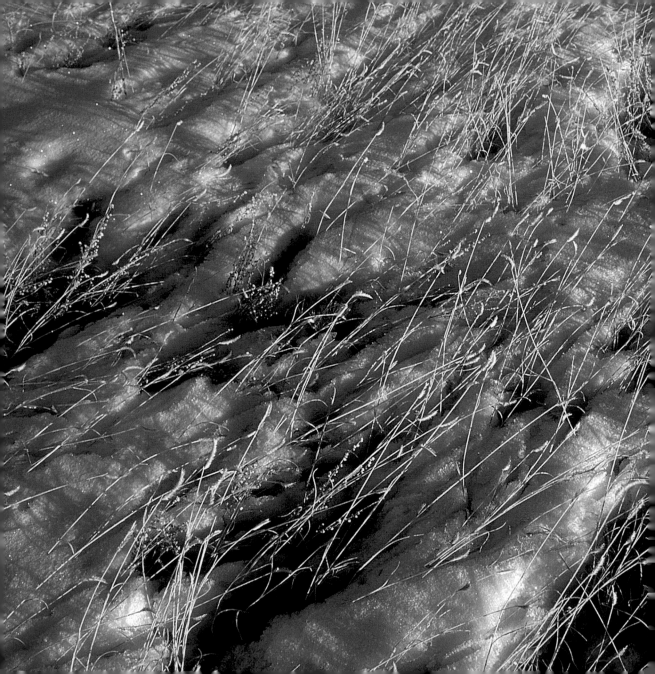

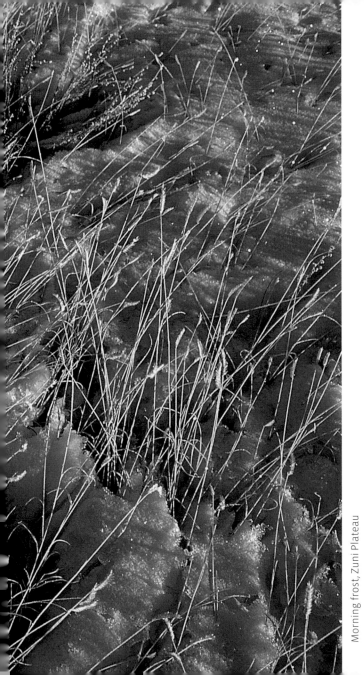

Morning frost, Zuni Plateau

"There was thin, crisp snow on the ground, the sky was blue, the wind very cold, the air clear."

—D. H. Lawrence, 1922,
"Wintry Peacock"

"The Rito is a beautiful spot. . . . Through the vale itself rustles the clear and cool brook to which the name of Rito de los Frijoles is applied. It meanders on, hugging the southern slope, partly through open spaces, partly through groves of timber, and again past tall stately pine-trees standing isolated in the valley. Willows, cherry-trees, cottonwoods, and elders form small thickets along its banks."

—Adolf F. Bandelier, 1890, *The Delight Makers*

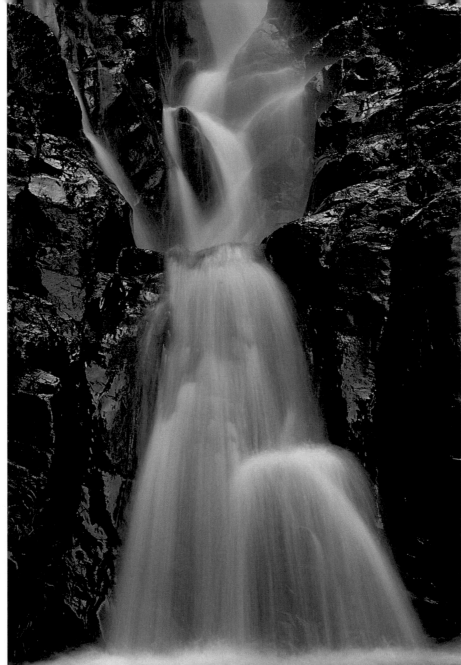

Sacred waters, Rito de los Frijoles

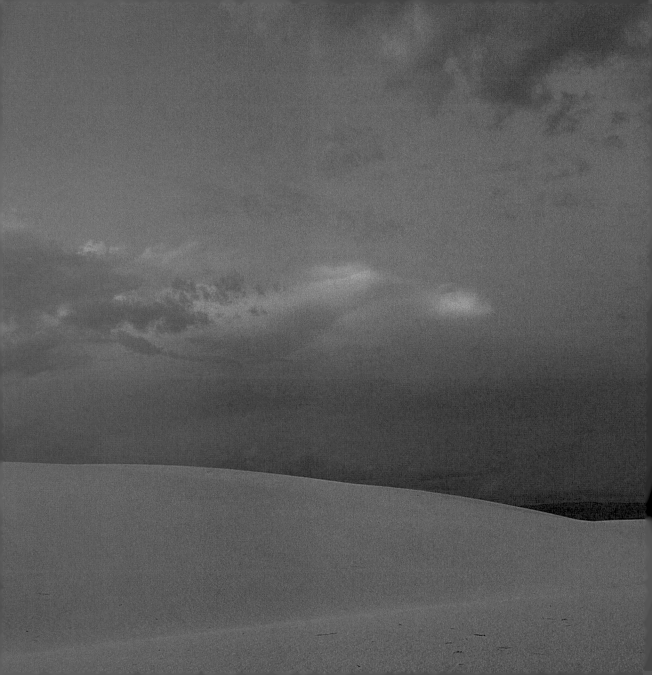

"Granted that they did not find the riches of which they had been told, they found a place in which to search for them."

—Pedro de Castañeda, 1540,
The Journey of Coronado

Terra Incógnita, "Unknown Country," Tularosa Valley

"The shades of evening falling upon us in our labors, we were constrained to retrace our way down to the plain; and it was not long before we were at the base of the rock, hovering over a bivouac fire, eating our suppers, and talking over the events of the day—the grim visage of the stupendous mass behind us occasionally fastening our attention by the sublimity of its appearance in the dim twilight."

—James H. Simpson, 1849,
*Journal of a Military Reconnaissance
from Santa Fé, New Mexico
to the Navajo Country*

El Malpaís, "Bad Country"

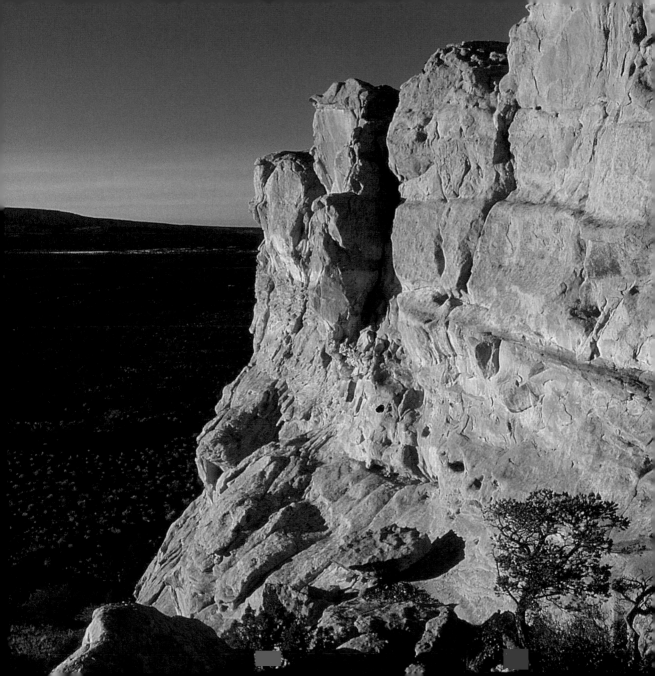

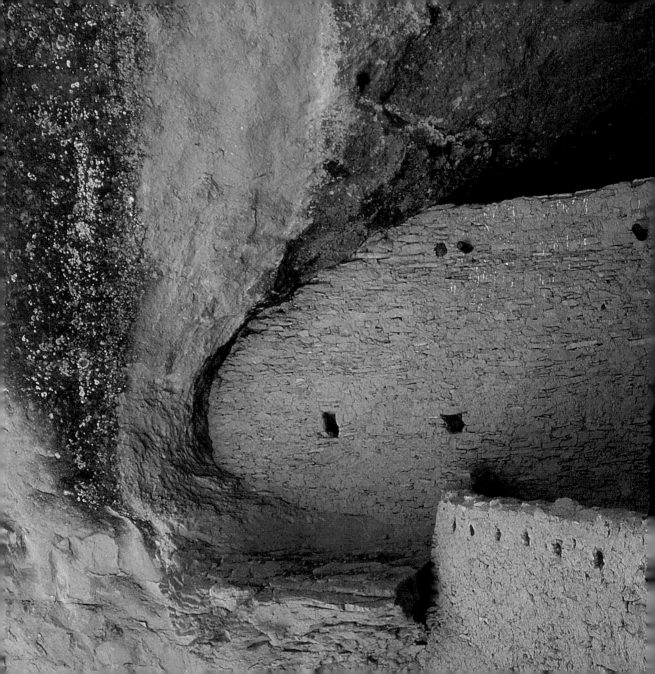

Gila Cliff Dwellings, headwaters of the Gila River

"In that country which lies around the headwaters of the Gila River I was reared. This range was our fatherland; among these mountains our wigwams were hidden; the scattered valleys contained our fields; the boundless prairies, stretching away on every side, were our pastures; the rocky caverns were our burying places."

—Geronimo, 1905–06,
Geronimo's Story of His Life

"The thorns on the climate, which, like the cactus, offers its glowing loveliness as well. That the sky is bluer, the sun more prevalent, the air fresher, the stars nearer, the moon clearer, and the days lazier, longer, and happier than anywhere else in the world is set forth in every chamber of commerce bulletin. They fail to note the beauty of starkness, of strength, of incalculable and invincible Nature, jealously guarding a beloved land that shall not be made into a kitchen garden."

—Erna Furgusson, 1940,
Our Southwest

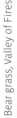

Bear grass, Valley of Fires

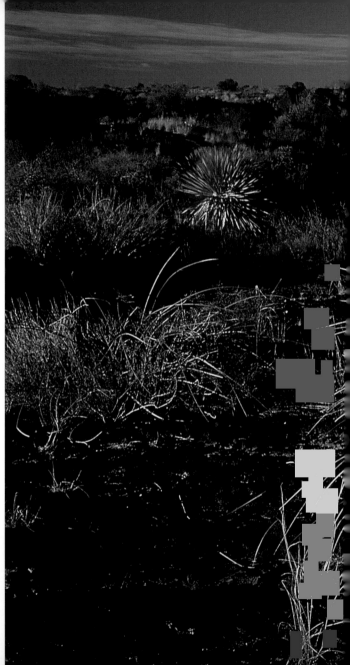

"Following the west or larger [creek] up two or three miles, we came upon a specimen of an old Cliff Dweller's village situated, as was their custom, in a crevice where there was good protection afforded by a wide, overhead ledge of projecting rock. In this case, from floor to roof was about eight or nine feet. The walls were of small, flat stones laid in common mud, with no door or window frames. The walls lacked twenty inches connecting with the roof, to give the smoke a chance to escape. They had fireplaces in the center of the apartments."

—Henry B. Ailman, 1878,
Pioneering in Territorial Silver City

Mogollon storage granary, Headwaters of the Gila River

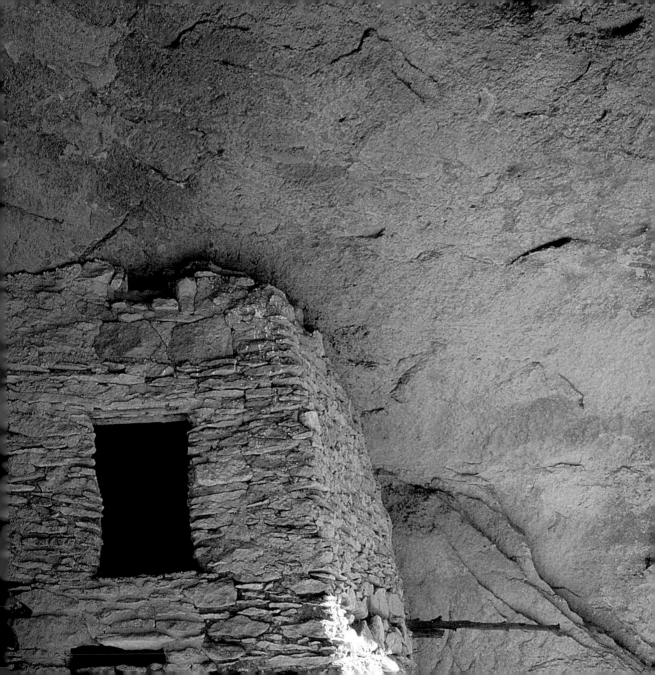

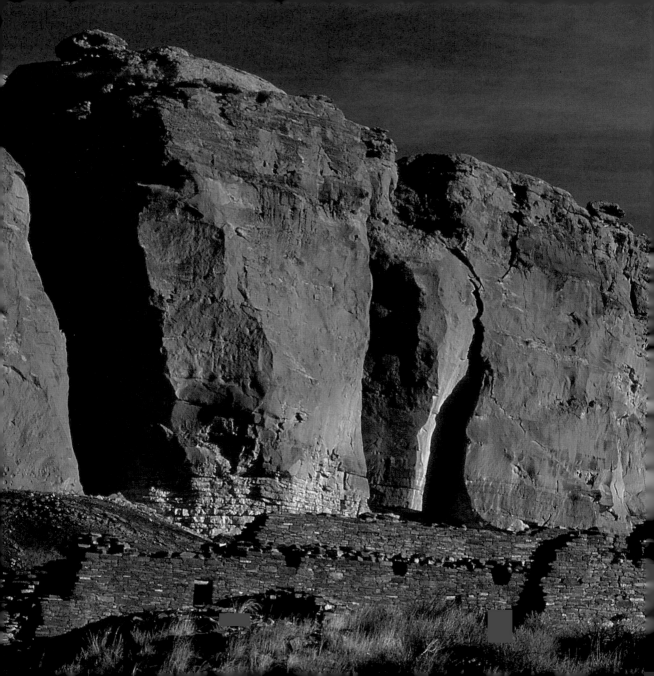

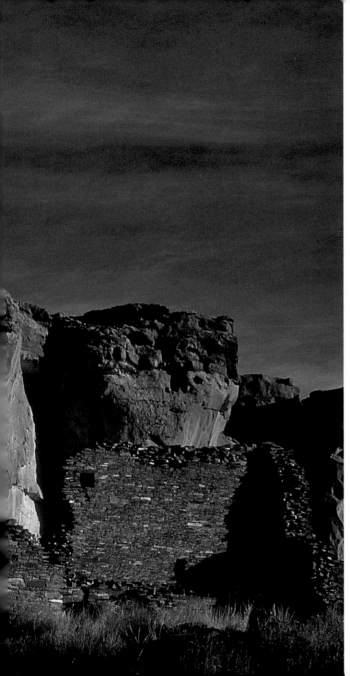

Pueblo Hungo Pavi, Mockingbird Wash. *Shongopovi,* "Reed Spring Village," Hopi village on Second Mesa

"Wherever the prehistoric Indian built, he always chose sites well defended by nature, as were the cliff dwellings, or easily defended by man, as were the Chaco Canyon villages, which stand in a plain over which no enemy larger than a coyote could approach unseen."

—Erna Furgusson, 1931,
Dancing Gods

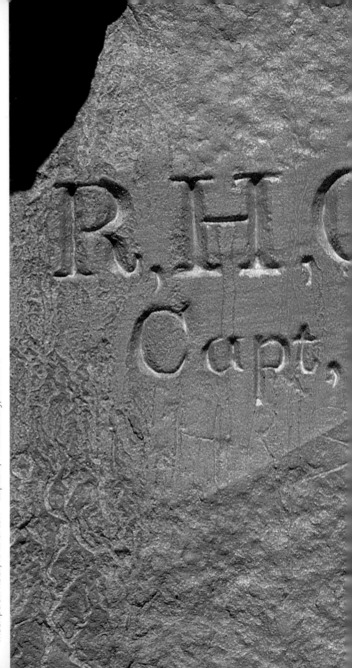

"And whereas, the rocks known as El Morro and Inscription Rock in the Territory of New Mexico, situated upon public lands owned by the United States, are of the greatest historical value and it appears that the public good would be promoted by setting aside said rocks as a national monument with as much land as may be necessary for the proper protection thereof;

"Now, therefore, I, THEODORE ROOSEVELT, President of the United States of America, by virtue of the power in me vested by section two of the aforesaid Act of Congress, do hereby set aside . . . the El Morro National Monument."

—Theodore Roosevelt, December 8, 1906, Proclamation 695

Inscription Rock, R. H. Orton—Captain, First Calvary, El Morro

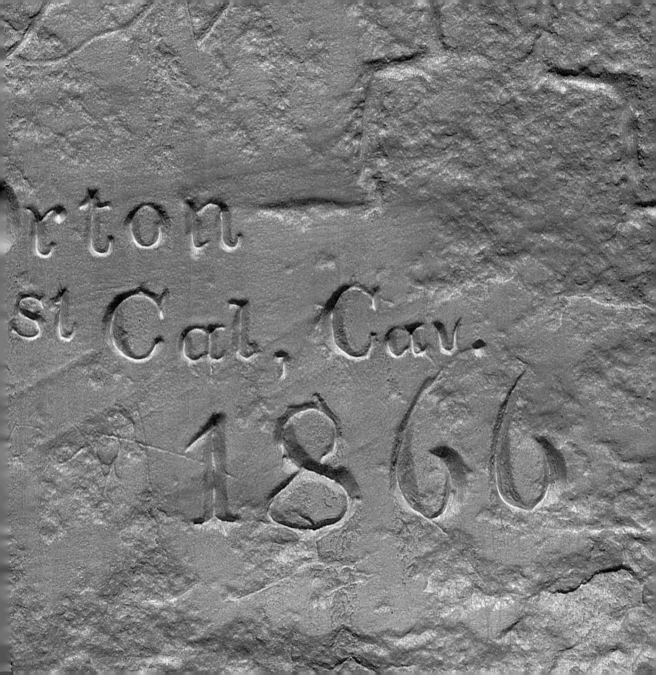

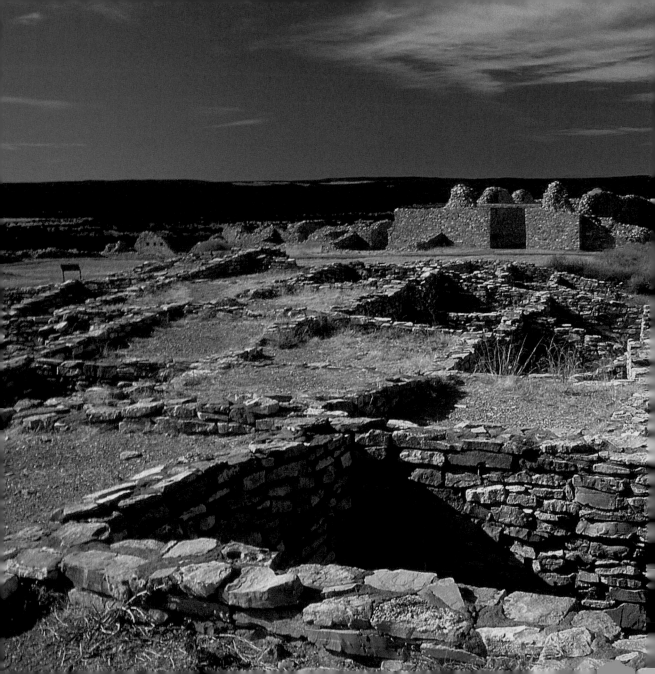

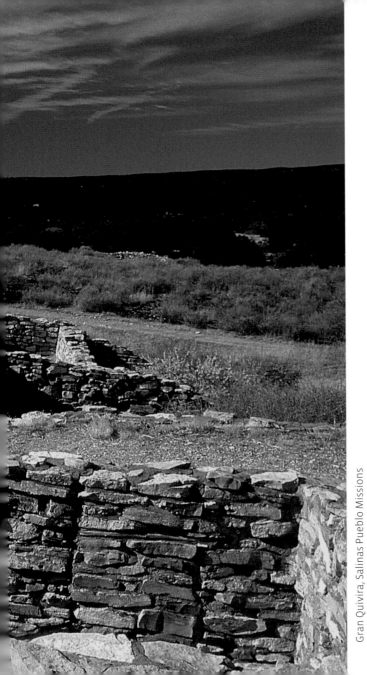

Gran Quivira, Salinas Pueblo Missions

"For three years no crop has been harvested. Last year, 1668, a great many Indians perished of hunger, lying dead along the roads, in the ravines, and in their hovels. There were pueblos, like Las Humanas, where more than four hundred and fifty died of hunger. The same calamity still prevails, for, because there is no money, there is not a fanege of maize or wheat in all the kingdom. As a result the Spaniards, men as well as women, have sustained themselves for two years on the cowhides they have in their houses to sit on. They roast them and eat them. And the greatest woe of all is that they can no longer find a bit of leather to eat."

—Fray Juan Bernal,
April 11, 1669, letter

"Resuming our journey, we passed two miles of very hilly pine-barren country—a mile further bringing us to a locality where, immediately on the right of the road, for the first time, some unseemly piles of blackened scoriaceous volcanic rock made their appearance. Three miles further, in a kind of basin, we met another series of piles of lava debris. . . . These piles look like so many irregular heaps of stone coal."

—James H. Simpson, 1849,
*Journal of a Military Reconnaissance
from Santa Fé, New Mexico to the Navajo Country*

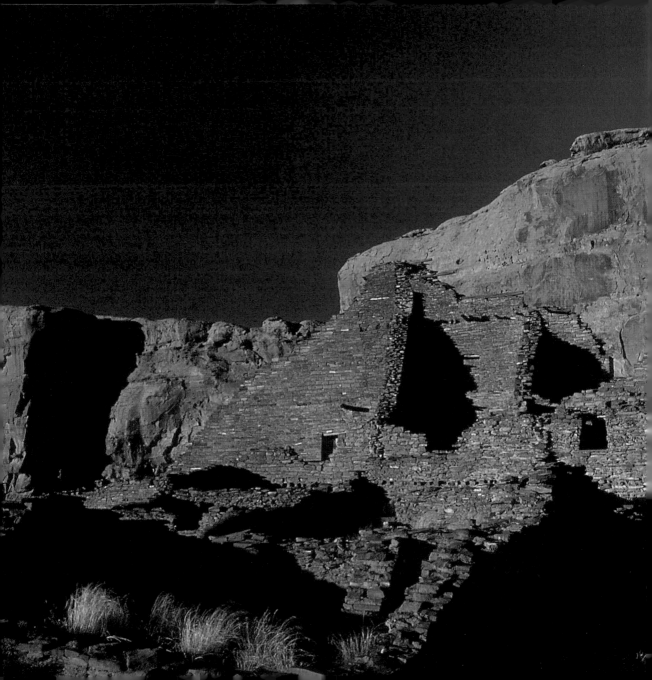

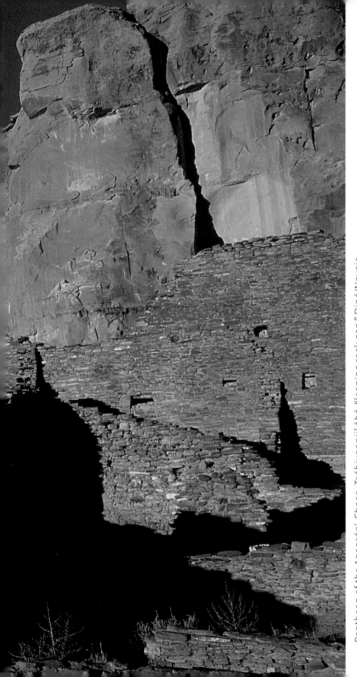

Pantheon of the Anaasází, Chaco. *Tsébíyaanii' áhá*, "leaning rock gap," Diné/Navajo

"Of the Chaco Ruins it is said: In size and grandeur of conception, they equal any of the present buildings of the United States, if we except the Capitol of Washington, and may without discredit be compared to the Pantheon and the Colosseum of the Old World."

—Emma C. Hardacre, 1878, "The Cliff Dwellers"

The sunbeams stream forward, dawn boys, with shimmering shoes of yellow.

On top of the sunbeams that stream toward us they are dancing.

At the east the rainbow moves forward, dawn maidens, with shimmering shoes and shirts of yellow dance over us.

Beautifully over us it is dawning. . . .

On the beautiful mountains above us it is daylight.

—P. E. Goddard, 1909,
"Gotal: A Mescalero
Apache Ceremony"

Shaman's dance, Sierra Blanca

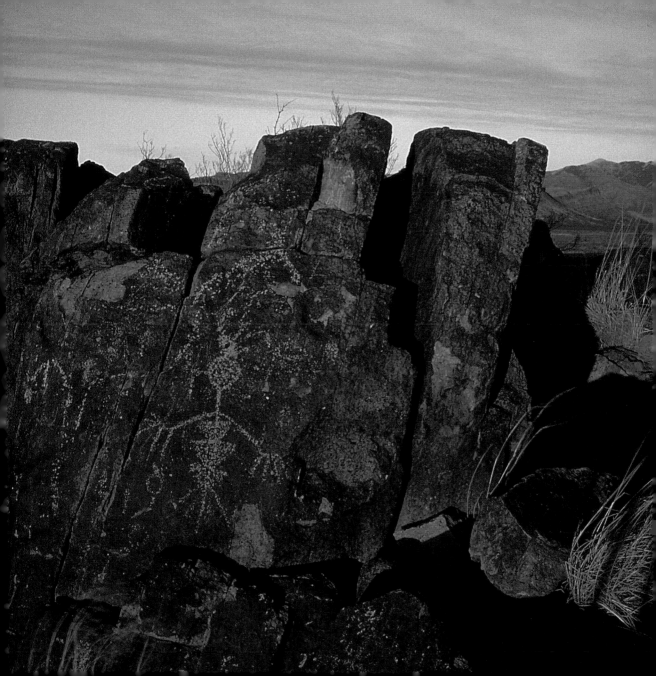

Literature Cited

TEXT

Page viii. *Epigraph*. From Frank Waters, "The Race Tracks at Chaco Canyon," *Book of the Hopi: The First Revelation of the Hopi's Historical and Religious Worldview of Life*. New York: Viking, 1963, p. 42.

Page ix. From Washington Matthews, *The Night Chant, A Navaho Ceremony*. New York: Memoirs of the American Museum of Natural History, 1902.

Page x. Waters, p. 43.

Pages x–xi. Willa Cather, *Death Comes for the Archbishop*. New York: Alfred A. Knopf, 1927.

Page xii. Juan de Jesús Romero, 1906, in *Indian Voices: The First Convocation of American Indian Scholars* by Jeannette Henry, Vine Deloria Jr., M. Scott Momaday, Bea Medicine, and Alfonso Ortiz, eds. San Francisco: The Indian Historian Press, 1970, p. 35.

INDIGENOUS NAMES IN TEXT AND CAPTIONS

John Annerino, "Glossary" in Indian Country: *Sacred Ground, Native People*. New York: W. W. Norton & Countryman Press, 2007, pp. 125–127.

Anonymous, "Chaco Canyon Place Names," Chaco Culture. National Historical Park, National Park Service, U.S. Department of the Interior, Revised August 2004, 2 pages.

PHOTOS

Photo 1. *Sierra del Olvido,* "Mountains of Forgetfulness." No photo quote.

Photo 2. Living landscape, White Sands. D. H. Lawrence, *St. Mawr and Other Stories*. New York: Alfred A. Knopf, 1925.

Photo 3. Pour over, City of Rocks. D. H. Lawrence essay "New Mexico," 1928. Online references only.

Photo 4. Shadow and light, White Sands. Gladys A. Reichard, *Spider Woman: A Story of Navajo Weavers and Chanters*. New York: Macmillan, 1934, p. 5.

Photo 5. Pueblo Bonito, Chaco. Juan de Jesús Romero, 1906, in *Indian Voices: The First Convocation of American Indian Scholars* by Jeannette Henry, Vine Deloria Jr., M. Scott Momaday, Bea Medicine, and Alfonso Ortiz, eds. San Francisco: The Indian Historian Press, 1970, p. 35.

Photo 6. Hoodoos, Bisti Badlands. Charles F. Lummis, *The Land of Poco Tiempo*. New York: Charles Scribner's Sons, 1893, p. 6.

Photo 7. Story-teller rocks, Three Rivers. Charles F. Lummis, *Pueblo Indian Folk-Stories* (enlarged new edition of *The Man Who Married the Moon*). New York & London: D. Appleton-Century Company, 1936, p. 1.

Photo 8. Rio Grande Gorge. Josiah Gregg, *Commerce of the Prairies or the Journal of a Santa Fé Trader, During Eight Expeditions across the Great Western Prairies, and a Residence of Nearly Nine Years in Northern Mexico,* illustrated with Maps and Engravings, in Two Volumes, Vol. I. Second Edition. New York: J. & H. G. Langley, & Astor House, 1845, p. 279.

Photo 9. Continental Divide, Bootheel Country. Anonymous, Pancho Villa recruitment poster, January 1915. Palomas, Chihuahua, México.

Photo 10. Mystery Mountain. Aldo Leopold, *A Sand County Almanac, and Sketches Here and There.* New York: Oxford University Press, 1949.

Photo 11. Twin pines, Cebollita Mesa. Mary Hunter Austin, *The Trail Book.* Boston and New York: Houghton, Mifflin & Co., 1918.

Photo 12. Río Grande, El Camino Real de Tierra Adentro. Paul Horgan, *Great River: The Rio Grande in North American History.* New York: Rinehart & Company Inc., 1954, p. 13.

Photo 13. Trails west, Lake Valley. Mrs. Alice Roberts, as told to Edith L. Crawford, March 7, 1938, Carrizozo, N.M. "Pioneer Story," p. 3. American Memory Collection, Library of Congress, Manuscript Division, WPA Federal Writers' Project.

Photo 14. Grandfather piñon tree, Valley of Fires. Arthur Chapman, *Out Where the West Begins: And Other Western Verses.* Boston and New York: Houghton, Mifflin & Co., 1917.

Photo 15. Peephole rock, City of Rocks. Maynard Dixon, 1875–1946. Quotation not attributed.

Photo 16. Frijole Falls, Bandelier. Charles F. Lummis in *The Delight Makers* by Adolf F. Bandelier. New York: Dodd, Mead & Co., 1890, Project Gutenberg, pp. xxv-xxvi.

Photo 17. Morning snow, Zuni Plateau. Charles F. Lummis, *The Land of Poco Tiempo.* New York: Charles Scribner's Sons, 1893, p. 139.

Photo 18. Casa de Alcove, Gallo Arroyo. Edgar L. Hewett, *Ancient Life in the American Southwest: With an Introduction on the General History of the American Race.* Indianapolis: Bobbs-Merrill, 1930, p. 179.

Photo 19. Badlands, Bistahí. John Annerino, *Desert Light: A Photographer's Journey through America's Desert Southwest.* New York: W. W. Norton & Countryman Press, 2006, p. 96.

Photo 20. Fragile moments, Bosque del Apache. Pat Floyd Garrett, *The Authentic Life of Billy The Kid, The Noted Desperado of the Southwest Whose Deeds of Daring and Blood Made His Name a Terror in New Mexico, Arizona and Northern Mexico. A Faithful and Interesting Narrative.* Santa Fé: New Mexico Printing and Publishing Co., 1882.

Photo 21. Ghost dunes, White Sands. Anonymous, no date, "The Legend of Pavla Blanca." White Sands National Monument, National Park Service Web site, Alamogordo, New Mexico. www .nps.gov/whsa/historyculture/pavla-blanca.htm.

Photo 22. First light, Chacra Mesa. John Louw Nelson, *Rhythm for Rain*. Boston: Houghton, Mifflin & Co., 1937, p. 220.

Photo 23. Lone pine, Cebollita Mesa. Aldo Leopold, *A Sand County Almanac, and Sketches Here and There*. New York: Oxford University Press, 1949.

Photo 24. Hand petroglyph, Three Rivers. Walter Hough, *The Hopi Indians: Little Histories of North American Indians, No. 4*. Cedar Rapids, Iowa: The Torch Press, 1915, p. 197.

Photo 25. The Faraway, Bisti/De Na Zin. Georgia O'Keeffe, 1941, correspondence.

Photo 26. Rimrock, El Malpaís. Cosmos Mindeleff, *The Cliff Ruins of Canyon de Chelly, Arizona*. Sixteenth Annual Report, Bureau of American Ethnology to the Secretary of the Smithsonian Institution. Washington: Government Printing Office, 1897, p. 6.

Photo 27. Circle-dot cross petroglyph, Three Rivers. Erna Furgusson, *Dancing Gods*. New York: Alfred A. Knopf, 1931, p. 11.

Photo 28. Old San Miguel Mission, Socorro. *Don Juan de Oñate, Colonizer of New Mexico, 1595–1628,* Two Volumes. George P. Hammond, Agapito Rey, eds. and trans. Santa Fé: Patalacio, 1927.

Photo 29. Sandstone Bluffs, Zuni-Acoma ancestral lands. Edmund J. Ladd, "Pueblo Uses of High Altitude Areas: Emphasis on the A:Shiwi-Zuni." Paper presented at the School of American Research Symposium, High Altitude Archaeology, October 1980: p. 6; published in *Adaptations in the Southwest*, ed. J. C. Winters. *Southwest Region Report,* no. 2 (1983): 168–176. U.S. Forest Service, Albuquerque.

Photo 30. The Point, El Morro. Charles F. Lummis, September 1, 1926, El Morro National Monument visitor center display.

Photo 31. Inscription Rock, El Morro. Mary Hunter Austin, *The Trail Book*. Boston and New York: Houghton, Mifflin & Co., 1918. Project Gutenberg, chapter XIV.

Photo 32. El Santuario de Chimayó, Rancho de Chimayó. L. Bradford Prince, *Spanish Mission Churches of New Mexico*. Cedar Rapids, Iowa: The Torch Press, 1915, p. 317.

Photo 33. Pueblo del Arroyo, "Town by the Stream." Edgar L. Hewett. *Ancient Life in the American Southwest: With an Introduction on the General History of the American Race*. Indianapolis: Bobbs-Merrill, 1930, p. 179.

Photo 34. Solstice point, Fajada Butte. Quotation excerpted with permission from "Anna Sofaer with Robert Wilder." *El Palacio* magazine, New Mexico Department of Cultural Affairs, Vol. 113, No. 3. (Fall 2008): 22–28.

Photo 35. Wetherill Cemetery, Chaco Canyon. Frank McNitt, *Richard Wetherill: Anasazi Pioneer Explorer of Southwestern Ruins, A Biography.* Albuquerque: University of New Mexico Press, 1966. Questia.com, p. 164

Photo 36. Moonrise, Taos Plateau. Haniel Long, "The Conspiracy." *Poems.* New York: Moffat, Yard & Co., 1920, p. 54.

Photo 37. Thunderbird rock, Tularosa Valley. John "Fire" Lamedeer quoted in *Lame Deer, Seeker of Visions: The Life of a Sioux Medicine Man* by John Lamedeer, Richard Erdoes, and John Fire. New York: Touchstone Books, 1973, p. 251.

Photo 38. Daybreak, Pueblo Bonito. Neil M. Judd, *The Material Culture of Pueblo Bonito, (with 101 plates) With Appendix Canid Remains from Pueblo Bonito and Pueblo del Arroyo* by Glover M. Allen. Publication 4171, Smithsonian Miscellaneous Collections, vol. 124, December 29, 1954: pp. vii, x, and xi.

Photo 39. Spanish inscription, El Morro. John Annerino on site photograph, Alejandrina Sierra translation, reference *Guide to the Inscription Trail* by Abbey Mogollón. Tucson: Western National Parks Association, 2008, p. 7. Historic source *Don Juan de Oñate: Colonizer of New Mexico, 1595–1628,* George P. Hammond and Agapito Rey, eds. and trans. Santa Fé: Patalacio, 1927.

Photo 40. Frozen silence, Bosque del Apache. Dane Coolidge, *Hidden Water* (with four illustrations in color by Maynard Dixon). New York: A. L. Burt Company, 1910, p. 191.

Photo 41. Goblins, Bisti Desert. Willa Cather, *Death Comes for the Archbishop.* New York: Alfred A. Knopf, 1927. Project Gutenberg.

Photo 42. Ancient walls, Pueblo Chetro Ketl. Erna Furgusson, *Our Southwest.* New York: Alfred A. Knopf, Borzoi Books, 1940, p. 127.

Photo 43. Morning frost, Zuni Plateau. D. H. Lawrence, "Wintry Peacock," from *England, My England, and Other Stories.* New York: T. Seltzer, 1922, p. 1.

Photo 44. Sacred waters, Rito de los Frijoles. Adolf F. Bandelier, *The Delight Makers.* New York: Dodd, Mead & Co., 1890. Project Gutenberg.

Photo 45. *Terra Incógnita,* Tularosa Valley. Pedro de Castañeda, 1540. *The Coronado Expedition, 1540–1542,* U.S. Bureau of American Ethnology, 14th Annual Report, Pt. 1. Washington: Government Printing Office, 1896, pp. 329–613; and *The Journey of Coronado: 1540–1542; from the City of Mexico to the Grand Canyon of the Colorado and the Buffalo Plains of Texas, Kansas, and Nebraska. As Told by Himself* [Francisco Vásquez de Coronado], *and His Followers* [Antonio de Mendoza, Pedro Reyes Casteñada, Juan Camilo Jaramillo]. Translated and edited by George Parker Winship, with map. New York: A. S. Barnes & Co., 1904.

Photo 46. El Malpaís, "Bad Country." James H. Simpson, *Journal of a Military Reconnaissance from Santa Fé, New Mexico to the Navajo Country*. Philadelphia: Lippincott, Grambo and Co., 1852, p. 103.

Photo 47. Gila Cliff Dwellings, headwaters of the Gila River. Geronimo, as told to his nephew Asa Daklugie in 1905–1906 and translated by him for S. M. Barrett, editor. *Geronimo's Story of His Life*. New York: Duffield, 1906, p. 17.

Photo 48. Bear grass, Valley of Fires. Erna Furgusson, *Our Southwest*. New York: Alfred A. Knopf, Borzoi Books, 1940, p. 13.

Photo 49. Mogollon storage granary, headwaters of the Gila River. Henry B. Ailman quoted in *Pioneering in Territorial Silver City*, Helen J. Lundwall, ed. Albuquerque: University of New Mexico Press, 1983, pp. 57–58.

Photo 50. Pueblo Hungo Pavi, Mockingbird Wash. Erna Furgusson, *Dancing Gods*. New York: Alfred A. Knopf, 1931, p. 9.

Photo 51. Inscription Rock, El Morro. R. H. Orton, Captain, First Calvary, El Morro. President Theodore Roosevelt, December 8, 1906, Proclamation 695, "Establishment of El Morro National Monument, Territory of New Mexico."

Photo 52. Gran Quivira, Salinas Pueblo Missions. Charles Wilson Hackett, ed., *Historical Documents Relating to New Mexico, Nuevo Vizcaya and Approaches Thereto, to 1773*. Carnegie Institution of Washington Publication, vol. 3, no. 330, Washington D.C.: 1937.

Photo 53. Zuni-Acoma Trail, El Malpaís. James H. Simpson, *Journal of a Military Reconnaissance from Santa Fé, New Mexico to the Navajo Country*. Philadelphia: Lippincott, Grambo and Co., 1852, p. 110.

Photo 54. Pantheon of the Anaasází, Chaco. Emma C. Hardacre, "The Cliff Dwellers," *Scribner's Monthly Illustrated Magazine,* Vol. 17, Issue 2 (December 1878): 266-276.

Photo 55. Shaman's dance, Sierra Blanca. P. E. Goddard, "Gotal: A Mescalero Apache Ceremony," p. 392, in *Putnam Anniversary Volume: Anthropological Essays*. New York: G. E. Stechert & Co., Publishers, 1909.

Acknowledgments

I am grateful to the talented and dedicated people at Globe Pequot Press who illuminated my vision of portraying New Mexico's mysterious landscapes in image, essay, literary quotes, and design: editorial director Erin Turner, cover designer Diana Nuhn, layout artist Maggie Peterson, project editor Meredith Dias, and text designer Sheryl P. Kober. I am also grateful to several book and magazine editors who had the confidence to send me on my formative travels throughout the canyons, mountains, and deserts of New Mexico: *LIFE* magazine picture editor Melvin L. Scott for sending me to Taos, New Mexico where I first glimpsed—and photographed—the mesmerizing depths of the Rio Grande Gorge; Sierra Club Books editor James Cohee, who first assigned me to photograph and write my impressions of the canyons and cliff dwellings for my book Canyons of the Southwest; and Countryman Press director Kermit Hummel, who gave me carte blanche to photograph the Malpaís, "Badlands," of Bisti De Na Zin, and far beyond for many books. And especially to my loving family. Thank you!

—John Annerino

About the Author

John Annerino is the author and photographer of seventeen distinguished photography books and thirty-two single-artist calendars, including *New Mexico Wild & Scenic* and *Ancient America,* and the award-winning books *Desert Light, Indian Country, Grand Canyon Wild, Canyons of the Southwest, The Wild Country of Mexico,* and *Roughstock: The Toughest Events in Rodeo.* His newest book, *The Virgin of Guadalupe,* will be published this year. John's credits include *Arizona Highways Magazine, National Geographic Adventure, Life, México Desconocido, Newsweek, People, Scientific American, Time, Travel & Leisure,* and other prestigious clients worldwide. In his quest to explore the renowned landscapes and hidden places of the Great Southwest with camera and pen over the last twenty-five years, John has climbed its hallowed mountains, rafted its wild and scenic rivers, journeyed on foot through its mystical chasms, and crossed its alluring deserts. He has photographed and come to know the region's Native peoples and ceremonies, Western cowboys and traditions, and Spanish heritage and celebrations.